Michelangelo

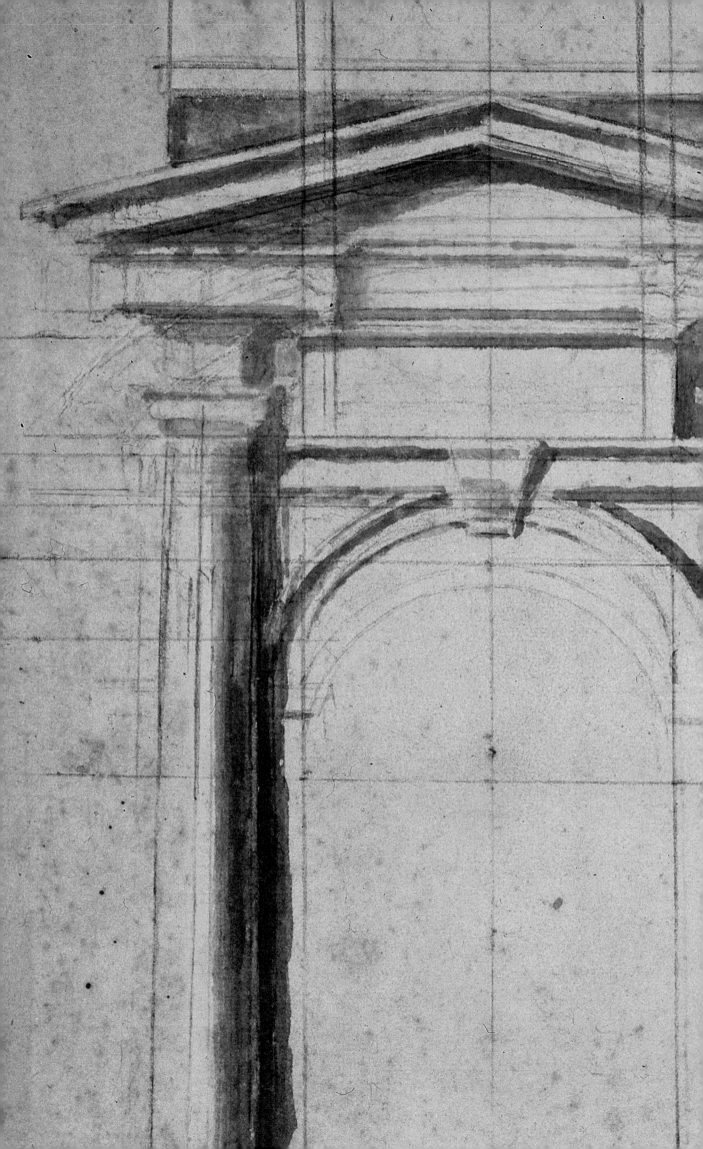

MICHELANGELO
THE MAN AND THE MYTH

PINA RAGIONIERI
Guest Curator

GARY M. RADKE
Scholarly Advisor

DOMENIC J. IACONO
Director, SUArtGalleries

Translated by
CHRISTIAN AND SILVIA DUPONT

SYRACUSE UNIVERSITY
ART GALLERIES

DISTRIBUTED BY UNIVERSITY OF PENNSYLVANIA PRESS

MICHELANGEO: THE MAN AND THE MYTH
was organized by the Casa Buonarroti and the SUArt Galleries

Exhibition Dates:

Syracuse University Art Galleries
Shaffer Art Building
Syracuse University, NY 13244

August 12 through October 19, 2008

The Louise and Bernard Palitz Gallery
Syracuse University Lubin House
11 East 61st Street
New York, New York 10065

November 4, 2008 through January 4, 2009

copyright ©2008 Syracuse University Art Galleries

Distributed by University of Pennsylvania Press
3905 Spruce Street
Philadelphia, Pennsylvania 19104-4112
www.pennpress.org

ISBN 978-0-8122-4148-8

This catalog was printed by Cohber Press, Rochester, NY
Catalog Design: Andrew Saluti, SUArt Galleries

cover:
Leoni, *Medal of Michelangelo*
frontispiece:
Michelangelo, detail, *Study of a Gate (Porta Pia?)*

CONTENTS

ACKNOWLEDGMENTS
7

DIRECTOR'S PREFACE
11

CURATOR'S INTRODUCTION
12

THE CASA BUONARROTI
15

THE LIFE AND WORKS OF MICHELANGELO
19

THE FACE OF MICHELANGELO
37

THE DRAWINGS OF MICHELANGELO
85

MICHELANGELO'S PIETÀ
118

EXHIBITION CHECKLIST
125

Acknowledgments

Syracuse University
and
The Syracuse University Art Galleries

Gratefully acknowledge the generous contributions
made by

LOUISE AND BERNARD PALITZ

toward

MICHELANGELO
THE MAN AND THE MYTH

Without their support this exhibition
would not have been possible.

Significant funding for this exhibition has been provided by

TIAA-CREF
Financial Services for the Greater Good™

Special thanks to

Susan and Washburn Oberwager

A generous contribution to the Michelangelo exhibition was made by the Oberwagers, who would like us to recognize their interest in *Olana*, a New York State Historic Site and National Historic Landmark that was once home to the important 19th Century American artist Frederic Church.

Thanks to

United Technologies, Inc. and its business unit Carrier Corporation

The Gladys Krieble Delmas Foundation

and

The Italian Cultural Institute

for their participation.

ACKNOWLEDGMENTS

Several years ago, Gary Radke, Dean's Professor of the Humanities at Syracuse University, and I met for a brief afternoon chat to discuss how the SUArt Galleries might display artwork from our collection for a class he was teaching. During our conversation I mentioned to him that our newly established Syracuse University Art Galleries (SUArt Galleries) was eager to bring together an exhibition that would utilize his talents and associations with notable Italian museums. On his next trip to Florence Gary discussed the idea of an exhibition for our galleries with his long time friend and colleague Pina Ragionieri, Director of the Casa Buonarroti. Within a few weeks Pina responded with the idea that has become *Michelangelo: The Man and the Myth.* We at Syracuse University are most grateful to them for their help, creative energies and talents, and willingness to make this exhibition happen.

Most, if not all, university museums and galleries rely on the beneficence of individuals who recognize the value of the arts in our lives. Syracuse University is fortunate to have such patrons in Louise and Bernard Palitz. These great friends of the SUArt Galleries have been truly magnanimous with their time and efforts to help raise the funds necessary for this exhibition. It has been more than twenty years since they made their first gift of art to the Syracuse University Art Collection and since that time they have assisted us with loans from their personal collection for our exhibitions, and with financial support for many of our activities. Our indebtedness to Louise and Bernard Palitz is heartfelt and sincere. They encourage our initiatives and share in the excitement of seeing them come to fruition.

All exhibitions are cooperative efforts that require the skill, expertise, and dedication of the museum staff. In the case of an international exhibition, especially when a figure such as Michelangelo is the subject of that exhibition, we truly rely on the collegial efforts of numerous individuals across the University campus. Beginning in early 2006 when the idea of this exhibition was being developed, we had the strong support of Syracuse University Chancellor Nancy Cantor. Her exciting initiatives, such as Scholarship in Action and Engagement with the World, foster an environment where we at the SUArt Galleries could think about such an exciting exhibition opportunity. The energy created by these initiatives was enhanced by such people as Thomas Walsh, Vice President for Institutional Advancement, and the Executive Director of the Coalition of Museums and Art Centers, Jeffrey Hoone. Every step along the way they have provided great support for our efforts.

Lil O'Rourke, Vice President for Institutional Advancement, and Charles 'Chuck' Merrihew, Associate Vice President for Institutional Advancement, cheerfully and ably guided us through a myriad of fundraising and budget issues. Our thanks to them and their capable staffs.

As always, the staff of the SUArt Galleries performed in an extraordinary manner using all their skills to make this exhibition possible and all the attendant activities associated with it memorable. Heartfelt thanks go to David Prince, Associate Director and Curator, Andrew Saluti, Exhibition Designer and Preparator, Laura Wellner, Registrar, Joan Recuparo, Office Manager, and Ingrid

'Alex' Hahn, Receptionist for their dedication and assistance in making this exhibition come to life. Sincere thanks also go to Emily Dittman, Associate Registrar, Maryanna Ramirez and Darin Stine, Graduate Assistants, Elaine Quick, Programs Coordinator, and Frank Olive, Assistant Director for the Warehouse Gallery.

Since this exhibition is taking place at two venues, the SUArt Galleries on the main campus and the Louise and Bernard Palitz Gallery at Syracuse University Lubin House, we needed and received tremendous support from numerous individuals at the House without whose assistance this exhibition would have never been possible. First and foremost I want to thank Patricia Dombroski, Executive Director of Lubin House Operations, and her exceptional staff of Lynn S. Clarke, Senior Director of Events, Jolanta Niwelt, Events Assistant, Lana Sagrin and Kristin Caiella, Administrative Assistants, and Oscar Mendez, Building Superintendent.

We are also indebted to our New York City colleagues Ruth Kaplan, Executive Director of Public Affairs and Marketing, Scott McDowell, Manager of Media and Special Events, Jeffrey Sperber, Regional Director of Development, Jane Henn, Senior Director of New York Programs, and Roslyn Black, Director of Corporate and Foundation Relations, who provided their expertise in a generous and helpful manner.

As one might imagine, the SUArt Galleries needed the assistance of numerous other University organizations to make this exhibition a reality. We are grateful for all the support given to this project by our Public Safety department, especially Chief Anthony Callisto, Jr., and his dedicated staff, including Andrea Stagnari, Michael Kearns, and Andrew Mrozienski. We also appreciate the assistance given to us by John Rossiter and Roger Stevens of the Safety Department at SU. We also need to acknowledge our Risk Management department including David Pajak and Linda Egerbrecht for their expertise.

The physical spaces that house the exhibition were improved significantly through the talents and skills of Robert Heaphy, Rex Giardine, John Osinski, Kevin Noble, and other members of the Office of Campus Planning, Design, and Construction. We appreciate their help with the design and oversight of improvements to our climate control systems that enabled us to maintain an optimal environment for the Michelangelo artwork.

We would like to thank our friends in the Physical Plant carpentry shop who helped us realize many of the design elements, including the imposing three-dimensional construction of Michelangelo's Porta Pia. In a most dramatic manner this feature of the exhibition helps our viewing public understand the brilliance of the renaissance master's design for a monumental gateway. The craftsmen at Physical Plant helped us transform the Lubin House building in New York and we are grateful to Joseph Guadagnola, Charles Esposito, and Brian Wheeler for their capable assistance.

Lastly we would like to express our gratitude to everyone not mentioned above who offered their expertise to this project. As stated earlier, this was a truly collaborative effort requiring the assistance of numerous individuals and colleagues. Thank you to all.

DIRECTOR'S PREFACE

Domenic Iacono
Director of the Syracuse University Art Galleries

In the four and a half centuries since his death, Michelangelo has been venerated as a genius of the Italian Renaissance and an artist who helped define the standard for what we call a 'renaissance' man. Although he may have considered himself first, and foremost, a sculptor, the world has also acclaimed his talents as painter, poet, architect, and military engineer. During his lifetime, biographers such as Giorgio Vasari elevated his position among artists to that of the quintessential artistic genius capable of creating works that must have been inspired by God. Authors have found his personality, full of apparent contradictions, to be the grist for fascinating stories about relationships, dedication to purpose, and emotional tirades worthy of the gods of Mt. Olympus. Art historians have placed him at the center of movements that changed the course of art. Many people consider his paintings in the Sistine Chapel as the most important work of art ever commissioned.

In Florence, a palazzo that bears his family name- the Casa Buonarroti- is today a museum dedicated to the life and art of the master. Through the efforts of his family and benefactors, such as the Medici, the Casa Buonarroti is now home to more Michelangelo drawings than any other institution in the world. The Casa also boasts one of most important archives and libraries of Michelangelo materials, seminal to any study of his art. In order to begin a study of the man and his genius, a visit to this museum is indispensable, unless one can manage to host an exhibition from its collection.

We are very fortunate to present an exhibition that principally uses Michelangelo's drawings and writings as a means of understanding the master. These images provide access to the creative process that is both intimate and expansive. For many artists, drawings are an intensely personal medium that allows us to see the creative process and reveal issues that enhance our appreciation of the piece. When combined with the written thoughts of Michelangelo, as expressed in his poetry, we are admitted to a very special place, that of genius and originality.

According to the Michelangelo biographer, John Addington Symonds, the artist once stated that "…drawing is the source and very essence of painting, sculpture, architecture, and of every form of representation, as well too as of all the sciences. He who has made himself a master in this art possesses a great treasure. Sometimes, when I meditate upon these topics, it seems to me that I can discover but one art or science, which is design, and that all the works of the human brain and hand are either design itself or a branch of that art."

It is truly a pleasure to present these rare and beautiful materials from the Casa Buonarroti. It is also a privilege to display them in a context that enhances our appreciation of these designs. The Study for a Gate (Porta Pia) is a dynamic drawing that at first glance appears to be a straightforward design of classical architecture. As a unique and signature design feature of this exhibition, Michelangelo's drawing, for the first time, has been transformed into a monumental three-dimensional construction. Aided by computer animations to help render its various elements, this assembly gives concrete evidence of how Michelangelo used the 'golden mean,' a ratio that helps develop harmony and balance in the relationship between the height and width of the structure.

We hope that this exhibition will be an opportunity for our university community, both in Syracuse and New York, to experience what many visitors to Florence, Italy encounter every day- art as a life altering experience.

CURATOR'S INTRODUCTION

Dottoressa Pina Ragionieri
Director of Casa Buonarroti

For those who work in the shadow of Michelangelo at Casa Buonarroti in Florence, the subject of this exhibition is naturally of the greatest interest: its first section speaks about the face of the Renaissance Master, the second presents a selection from one of the most precious properties of the institution I have been directing for many years: that is, the collection of original drawings by Michelangelo.

Michelangelo was not fond of portraying himself or of being portrayed by others. Vasari writes: "Of Michelangelo there are but two painted portraits ... and there is a bronze portrait in full relief made by Daniello Ricciarelli, as well as this famous one by Cavalier Lione, of which so many copies have been made..." Only a few additions can be made to Vasari's brief list, one of the most important of which is the watercolor by Francisco de Hollanda, a singularly domestic picture of Michelangelo, who is seen at over the age of seventy.

Still, the fame of Michelangelo meant that large numbers of engravings and pictures were made in the sixteenth century. About a hundred were cataloged by Ernst Steinmann, who in 1911 organized the first and, as far as we know, the only exhibition of portraits of Michelangelo to have been put on to date. In 1913 he published a monumental book on the subject. The book is present in our exhibition, open to the page with the reproduction of the famous watercolor by Francisco de Hollanda.

But the image of Michelangelo has also come down to us through other types of portraits: artists used his features in groups of figures in their works. We find many examples of these, including Raphael in his *School of Athens* in the Stanza della Segnatura in the Vatican. And writers, most notably Condivi and Vasari, described him in their biographies, even down to the detail of certain streaks, wavering between gold and blue, in the great Master's eyes.

Ernst Steinmann wrote: "Michelangelo let the fire of his friendship express himself more willingly with his pen than with his brush or scalpel." It is a very similar conviction that leads us to suggest, in the first section of our exhibition, an "inner" portrait of the artist, not only through the "written portraits" he made, but also through his poetry. Together with Steinmann's great book – it will be possible to see autograph poems by the great Master, and some editions of his verses.

The second section of our exhibition shows a good number of drawings by Michelangelo, coming from the Casa Buonarroti Collection. As the demands of conservation make it impossible to place the graphic works permanently on show, only small samples of the collection are displayed in rotation in the Casa Buonarroti Museum. I am therefore very happy to share some of these treasures with our friends in Syracuse and New York, painting a unique portrait of the artist through his words and his drawings.

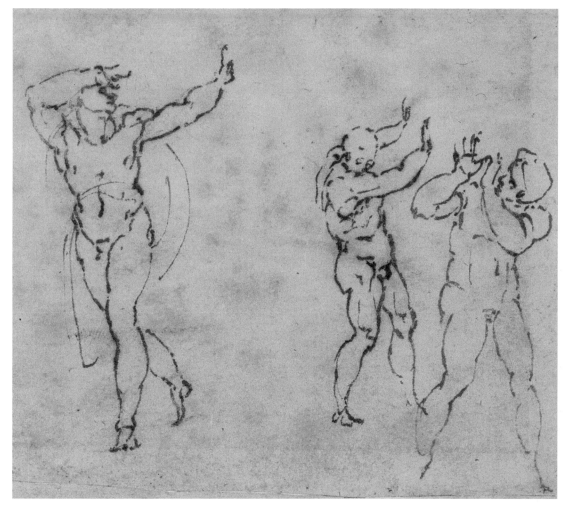

Michelangelo, detail, *Three Nudes*

Curatorial Notes

All catalog entries were written by Dottoressa Pina Ragionieri unless otherwise noted.

Other entries were composed by
[E. L.] Elena Lombardi
[E. M.] Elena Marconi
[G. N.] Gregorio Nardi
[D. I.] Domenic Iacono

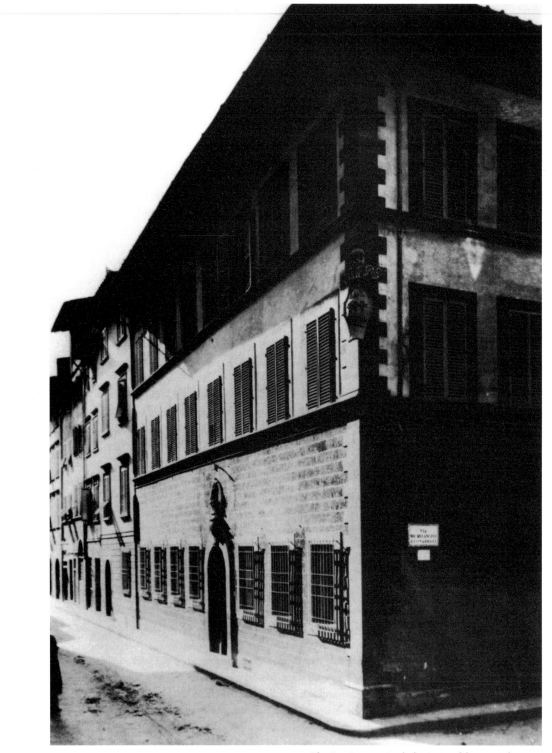

The Casa Buonarroti at the beginning of the twentieth century

THE CASA
BUONARROTI

A museum and a monument, a place of memory and of celebration of the genius of Michelangelo and, at the same time, a sumptuous baroque display and exhibition of the rich art collections of the family, the Casa Buonarroti offers one of the most unique visitor experiences among the many museums of Florence. First of all it offers the pleasure of seeing two famous reliefs in marble, masterpieces of the young Michelangelo: the *Madonna of the Stairs*, an intense witness to his passionate study of Donatello, and the *Battle of the Centaurs*, an eloquent testimony of unquenched love for classical art.

No less meaningful for those who enter the great doors of the seventeenth-century palace in Via Ghibellina 70 in Florence, is connecting the works of Michelangelo to the worldly affairs of the Buonarroti family. They spared no expense in enlarging and decorating their residence—a place where they preserved a precious cultural heritage (including important archives and a library) and rare collections of art: paintings, sculptures, ceramics, and archaeological objects which today are displayed on the two floors of the museum.

On the second floor, a specially furnished room presents a rotating display of selections from the Casa's collection of two hundred and five precious sheets by Michelangelo. Let us briefly recall their history.

In a famous passage from his biography of Michelangelo, Giorgio Vasari says that the artist, as a sign of his desire for perfection, decided, before his death in Rome in 1564, to burn "many drawings, sketches, and cartoons made with his own hand, so that no one would see the labors he endured and the ways he tried out his own genius, in order to appear nothing but perfect." Fortunately, when he died, many of Michelangelo's drawings were in Florence in the hands of the family, and his nephew Leonardo recovered more of them in Rome. Around 1566 his nephew gave the Duke of Tuscany, Cosimo I dei Medici, a goodly number, in order to satisfy his collecting desires, as well as the *Madonna of the Stairs* and what was still left in Michelangelo's studio in Via Mozza, which he had left thirty years earlier when he moved from Florence to Rome.

When, more than fifty years after the death of Michelangelo, his great nephew Michelangelo Buonarroti the Younger decorated a series of rooms in the family residence in his memory, Grand Duke Cosimo II returned the *Madonna of the Stairs* and some of the drawings donated to the Medici family. Meanwhile, the mindful descendent went about recovering other autograph drawings of Michelangelo at great expense, even from the Roman market.

The Buonarroti family's collection of Michelangelo's papers was at this point the richest in the world—and still is, with its more than two hundred pieces, despite all the serious assaults it has suffered. At the end of the eighteenth century the collection was impoverished when the revolutionary Filippo Buonarroti, already exiled in Corsica, made an initial sale to French painter and collector Jean Baptiste Wicar. In October 1858, the collection was further reduced when Cavalier Michelangelo Buonarroti sold some sheets to the British Museum. A few months earlier, Cosimo

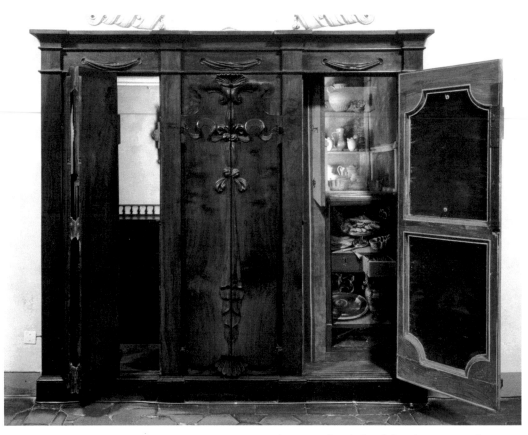

'Writing Cabinet' of Michelangelo Buonarroti the Younger

Buonarroti, last direct heir of the family, had died. He owned the largest part of Michelangelo's papers, including the drawings. In his will he left them all to be enjoyed by the public, together with the palace in Via Ghibellina and its contents.

Beginning in 1859, the precious drawings were left exposed for long years in frames and showcases in the Casa Buonarroti, which had become a museum. It was not until 1960 that they were withdrawn from such careless custody. They were then taken to the Prints and Drawings Department of the Uffizi and restored. Only in 1975 were they returned to Casa Buonarroti. At present, the rotating display of the invaluable sheets within the museum adheres to the most current conservation principles.

The significance of Casa Buonarroti is not limited, however, to the celebration of such an extraordinary figure as Michelangelo, although it possesses and exhibits works and documents about him that are enriched by gifts added to the family patrimony or pieces consigned on deposit by Florentine museums. Among these, two famous works by Michelangelo, the *Wooden Model for the Façade of San Lorenzo* and the enthralling *River God*, a large preparatory model for a statue that was never made for the New Sacristy. There are also the two sixteenth-century *Noli me tangere* paintings, which are based on a lost preparatory cartoon by Michelangelo.

The idea to create a sumptuous building to glorify the family and especially its great ancestor goes back to the above mentioned Michelangelo Buonarroti the Younger, an eminent literary figure and cultural leader who, beginning in 1612 and for approximately the next thirty years, employed on

the palace interior and particularly in the gallery and its three adjacent rooms the greatest artists working in Florence: from Empoli to Passignano, from Artemisia Gentileschi to Pietro da Cortona, from Giovanni da San Giovanni to Francesco Furini and the young Jacopo Vignali. In these splendid rooms, Michelangelo the Younger placed the most valuable pieces of his collection, many of which are still part of the museum tour, among them, a wooden predella with *Stories of St. Nicholas*, the masterpiece of Giovanni di Francesco, a follower of Domenico Veneziano.

In the life of an institution whose principal goal is research, one cannot forget the annual schedule of exhibitions relating to the cultural, artistic, and historical heritage and memories of Casa Buonarroti that go beyond Michelangelo and his time.

For many years now, such exhibitions have gained international renown, both for the value of the loans and originality of the themes addressed and also for the sound scholarship of the catalogs that accompany them.

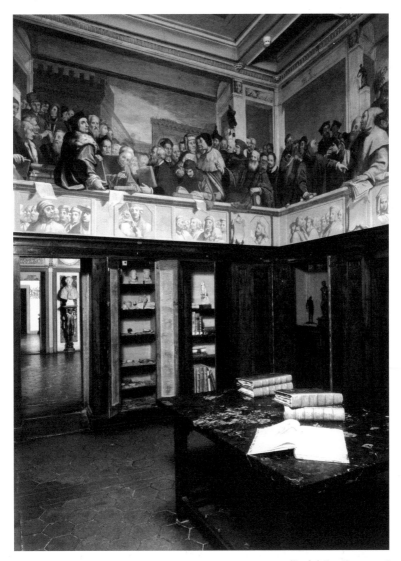

'Study,' Casa Buonarroti

THE LIFE AND WORKS OF
MICHELANGELO
(Caprese 1475—Rome 1564)

Michelangelo was born in Caprese, in the province of Arezzo, on March 6, 1475 to the Florentine Ludovico Buonarroti, who at the time was podestà of Chiusi and Caprese, and to Francesca di Neri di Miniato del Serra. At the end of his term, Ludovico returned to Florence with his family, and Michelangelo was entrusted to a wet nurse in Settignano who belonged to a family of stonemasons. According to Michelangelo's biographer Ascanio Condivi, who wrote under the guidance of the artist himself, it was this fact, together with his birth under the favor of Mercury and Venus that caused his precocious inclination to the art of sculpture.

Michelangelo, who for his whole life continued to define himself as a "sculptor," began his apprenticeship in the workshop of the painters Domenico and David del Ghirlandaio in 1487. He was introduced by his friend Francesco Granacci, against the will of his father, who had pledged him to instruction by the grammar master Francesco da Urbino. Michelangelo's frequenting of the Ghirlandaio workshop lasted only briefly. In fact, he was accepted in the Garden of San Marco, where Lorenzo the Magnificent was assembling his collection of antiquities and admitting young artists so that they might be formed by the example of classic art under the direction of the sculptor Bertoldo di Giovanni. Alongside the passionate study of antiquity, Michelangelo meditated profoundly on the artists of the recent and glorious past of his city. Indeed, his drawings bear witness to his interests in Giotto, Donatello, and Masaccio, in whose works, more than in those of artists from the second half of the century, he found confirmation of his aesthetic ideal of robust and essential monumentality.

Belonging to the period he spent in the home of Lorenzo the Magnificent (between 1490 and 1492), are two reliefs in marble that today may be seen in the Casa Buonarroti—the *Madonna of the Stairs* (fig. 1) and the *Battle of the Centaurs* (fig. 2)—the earliest works that can be securely attributed to Michelangelo. In them, he already displayed the stature of a mature artist. In the first, there is an explicit reference to Donatello; in the second, to classical sculpture. But their comparison, instead of leading to the conclusion that they were directly derived from these models, shows a deep assimilation and movement beyond them.

Upon the death of Lorenzo, Michelangelo left the Medici Palace to return to his family home, where he sculpted a *Hercules* in marble that was subsequently placed in the Strozzi Palace. In 1529, during the siege of Florence, it was sold by Giovan Battista della Palla to Francis I, the king of France, who installed it at Fontaineblaeu, in the Garden of l'Etang. Michelangelo also executed a *Crucifix* in wood for the prior of the Convent of Santo Spirito in Florence, which Margrit Lisner, along with many critics, has recognized in the work that after having been held by Casa Buonarroti for more than thirty years, was returned to its original location in December 2000.

The years following the death of Lorenzo the Magnificent were very turbulent for the city of Florence, which was then governed by Piero de' Medici and inflamed by the preaching of the Dominican friar Girolamo Savonarola. In October 1494, Michelangelo left Florence to take refuge in Venice. His sojourn in the lagoon city was nevertheless short because he decided to move to

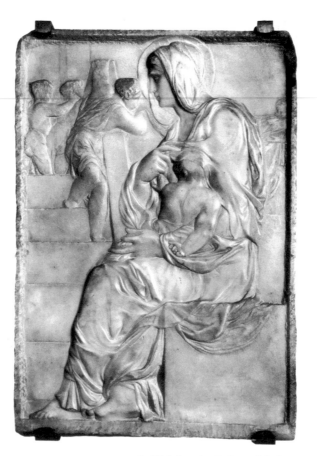

1. Michelangelo, *Madonna of the Stairs*

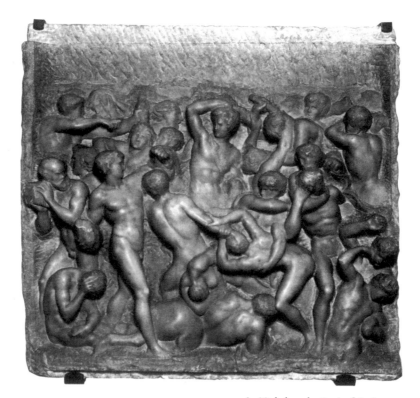

2. Michelangelo, *Battle of the Centaurs*

Bologna, where he was a guest of Gian Francesco Aldrovandi. Thanks to Aldrovandi, he obtained a commission for three statues to further work on the Arca di San Domenico, which was begun in the times of Nicola Pisano and which still remained incomplete at the death of Niccolò dell'Arca. Michelangelo carved an *Angel Holding a Candlestick*, to match the one executed by Niccolò, yet characterized by a robust physicality and intimate dynamism. It is a reminder of the influence of Jacopo della Quercia, who had left in San Petronio in Bologna one of the greatest examples of his art. Michelangelo also executed statues of *St. Procolus* (fig. 3) and *St. Petronius*, in which one can sense him updating the painters of Ferrara as well as Jacopo della Quercia.

3. Michelangelo, *St. Procolus*

After about a year, Michelangelo went back to Florence, where he was received by Lorenzo di Pierfrancesco de' Medici, a cousin of the exiled Piero but with republican ideals, who commissioned from him a *Young St. John* sculpted in marble, since lost. Also thanks to Lorenzo, Michelangelo succeeded in selling a *Sleeping Cupid* as an antique on the Roman market. It was purchased by Cardinal Raffaele Riario, who, having discovered the trick, demanded his money back, but also recognized the talent of the young sculptor. He called Michelangelo to Rome and commissioned from him the *Bacchus* which today is in the Bargello (fig. 4). During this first Roman sojourn, he lived and worked in the home of the banker Jacopo Galli, for whom he executed another statue inspired by antiquity, which sources record as either a *Cupid* or *Apollo*. Galli also soon came into possession of the *Bacchus*, which probably never found its way to the Cancelleria Palace, and favored his guest with important commissions. Indeed, three contracts name Jacopo Galli as guarantor.

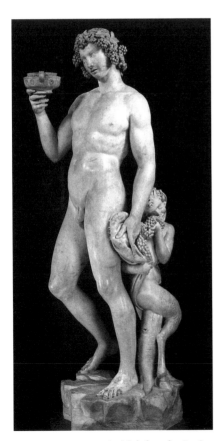

4. Michelangelo, *Bacchus*

On August 27, 1498, Michelangelo signed his first contract for a public work, a *Pietà* (fig. 5) in marble, requested by Cardinal Jean Bilhères of Lagraulas, ambassador of Charles VIII to the papal court, for the Chapel of the Madonna della Febbre. The *Pietà*, today in St. Peter's basilica in the Vatican, is the only work signed by Buonarroti. It represents one of the highest achievements of the artist, not only for the virtuosity with which he rendered the tactile sense of the surfaces and the anatomical perfection, but also for the psychological intensity of the grouping, in which the tragic event is sublimated in a tranquil meditation on the mystery of the Incarnation and Redemption.

Jacopo Galli also surely played an important role in the commission of an altarpiece for the church of Sant'Agostino, mostly likely the *Entombment of Christ* which is now in the National Gallery, London (fig. 6). It remained unfinished in the spring of 1501 when Michelangelo left Rome for Florence. The *Entombment*, nevertheless, is not the only painting Buonarroti executed during his Roman sojourn. Vasari mentions the *Stigmatization of St. Francis* which Michelangelo would have painted—or rather for which he would have supplied the cartoon to a painter, recently identified as Piero d'Argenta, a collaborator of Buonarroti from Ferrara. According to Hirst, the panel representing the *Madonna with the*

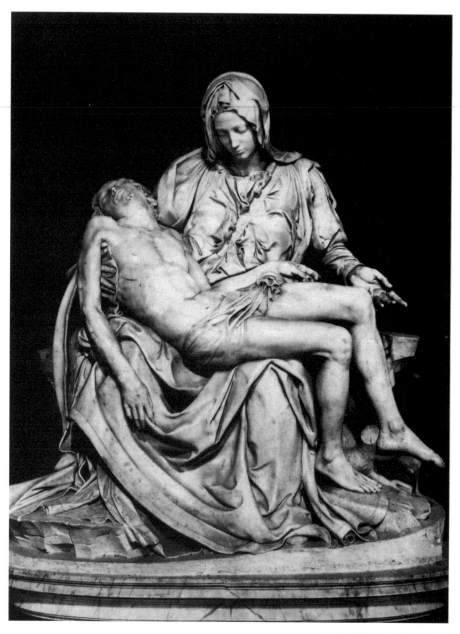

5. Michelangelo, *Vatican Pietà*

Christ Child, St. John, and Angels, known as the *Manchester Madonna* (fig. 7), was also begun in Rome, referred to in a payment of June 1497.

Michelangelo left Rome in March 1501, having been summoned, according to Vasari, "by several of his friends ... because it was not out of the question that from that ruined marble block that was in the Opera he might carve a figure, as he had already wanted to do." It is nevertheless not clear whether he returned to Florence for the commission of the statue of *David* (fig. 8), to which his Aretine biographer refers, or for an earlier one, for which he would have already made the agreements in Rome, as the presence of Jacopo Galli as guarantor seems to confirm. In fact, the contract that Michelangelo signed with Cardinal Francesco Todeschini Piccolomini, the future Pope Pius III, was dated June 5, 1501. According to the contract, Michelangelo was to execute (in the place of Pietro Torrigiano, a Florentine sculptor who was a contemporary of Michelangelo and

who, like him, was educated in the Garden of San Marco) fifteen statues for the completion of the Piccolomini Altar in the cathedral of Siena, created by Andrea Bregno (1483-85).

Of the fifteen statues that were envisioned, only four were executed, *St. Peter*, *St. Paul* (fig. 9), *St. Pius* and *St. Gregory*, because in the meantime Michelangelo was busy in Florence with much more important commissions. In fact, not only was he working on the block of marble at the Opera del Duomo, from which he carved the *David* (fig. 8), finished in 1503 and placed in the Piazza della Signoria in 1504 as a symbol of civic virtues (today it stands in the Galleria dell'Accademia in Florence), but the four years of his Florentine sojourn were particularly filled with public and private commissions. In August of 1502, he received from the gonfaloniere Pier Soderini and the eight priors the charge to execute a *David* in bronze for Pierre de Rohan. In April of the following year, he agreed to create statues in marble of the twelve apostles to be placed in the interior of the Duomo in Florence, of which there remains only the unfinished *St. Matthew*, preserved in the Galleria dell'Accademia in Florence (fig. 10). In December 1503, payments began for another work in marble, a *Madonna and Child* (fig. 11) commissioned by the Flemish merchant Alexandre Mouscron and destined for his chapel in the cathedral of Bruges. Yet the most important commission came to him in the summer of 1504, when Soderini proposed to have frescoed an episode of the *Battle of Cascina* on a wall of the Sala Grande del Consiglio in the Palazzo Vecchio, where Leonardo was already painting the *Battle of Anghiari*. This grandiose project, which permitted Michelangelo to measure himself against the art of the older master, remained unfinished on account of his departure from Florence. He executed only preparatory designs and the cartoon which all of Buonarroti's contemporaries and younger artists studied and which Vasari called "more a divine than human creation." The remains of the cartoon were preserved during the 1500s in Mantua by the Strozzis and during the 1600s in Torino in the Sabaudian collections.

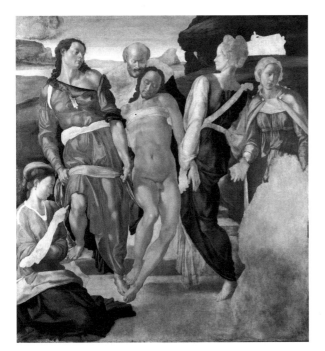

6. Michelangelo, *Entombment of Christ*

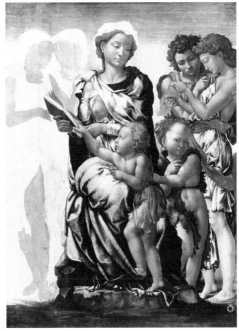

7. Michelangelo, *Manchester Madonna*

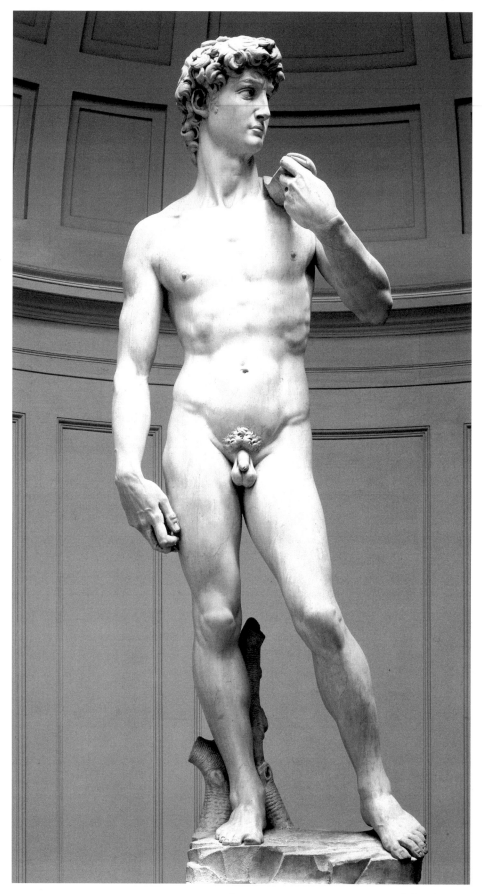

8. Michelangelo, *David*

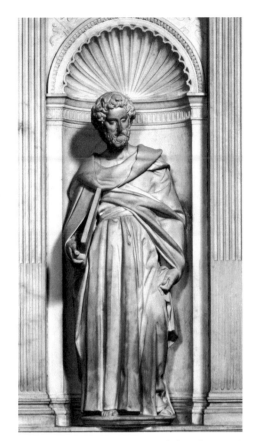

9. Michelangelo, *St. Paul*

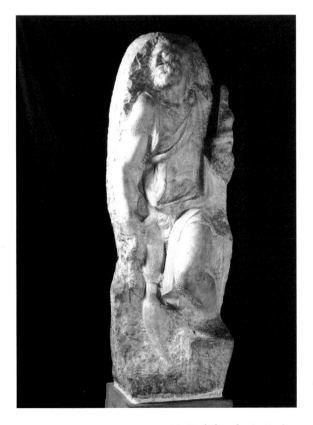

10. Michelangelo, *St. Matthew*

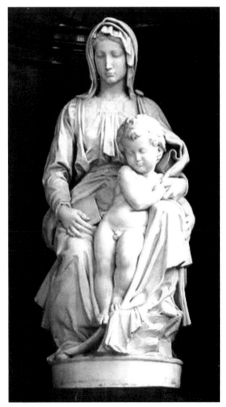

11. Michelangelo, *Bruges Madonna and Child*

Several important private commissions also date to these years. To these Michelangelo dedicated equal effort and innovative tension. They consist of two round marbles depicting a *Madonna and Child with a Young St. John the Baptist*, sculpted for Taddeo Taddei (London, Royal Academy of Fine Arts; fig. 12) and Bartolomeo Pitti (Florence, Museo Nazionale del Bargello; fig. 13), and also the *Holy Family with the Young St. John the Baptist* (fig. 14), which he painted for Agnolo Doni, and which today is displayed in the Galleria degli Uffizi.

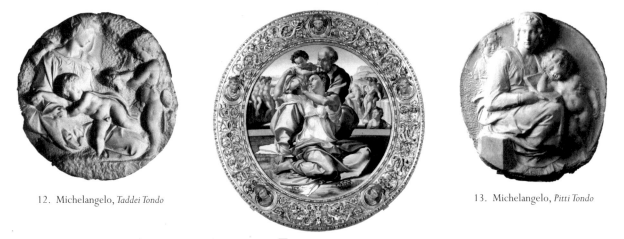

12. Michelangelo, *Taddei Tondo*

13. Michelangelo, *Pitti Tondo*

14. Michelangelo, *Doni Tondo*

In March 1505, Michelangelo returned to Rome, having been called by Pope Julius II, who requested that he create for the Vatican basilica his own mausoleum. According to his intentions, it would have to be a grandiose work, one that would exceed in size and beauty every other ancient and modern monument. Michelangelo proposed an independent structure, rectangular in form, consisting of three levels decorated with marble statues and bronze reliefs. Once the project was approved, Michelangelo went to Carrara to look for marble, but upon his return to Rome, the pope had already changed his mind and abandoned the ambitious plan. Deeply hurt by this behavior, Michelangelo left the city, with papal emissaries pursuing him to no avail. Thus began what Condivi, surely borrowing the words of the artist, called the "tragedy of the tomb," a torment that lasted forty years.

The reconciliation between the two took place in Bologna at the end of 1506, and was sealed by the commission of a bronze portrait of the pope to be installed in a niche on the facade of San Petronio. Having finished this work (which was destroyed just five years after the restoration of the Signoria of the Bentivoglio), Michelangelo returned to Rome to paint the frescoes on the ceiling of the Sistine Chapel—a charge he accepted with a certain reluctance and which he pursued in complete isolation. He experienced it as a challenge not only for the vastness and difficulty of the labor, but also for the desire to go beyond the limits imposed by tradition and those which he himself had attained. The vaulted ceiling, frescoed with the story of humanity *ante legem*—before the Law of Moses—and with the figures of Prophets and Sibyls and of the forebearers of Christ, was finished in 1512, after four years of intense labor. Shortly afterwards Julius II died, and Michelangelo signed with his heirs a new contract for the pope's funerary monument that redefined the grandiose dimensions of the preceding version. For this project, Michelangelo executed two statues of *Prisoners* (fig. 15), now at the Louvre, and *Moses* (fig. 16), which was later recovered for the final version of the tomb in the church of San Pietro in Vincoli in Rome.

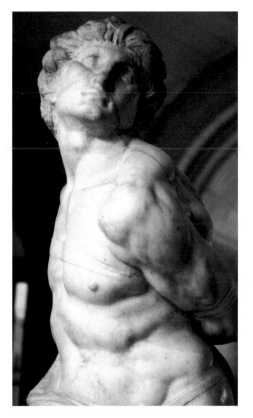

15. Michelangelo, detail, *Rebellious Slave*

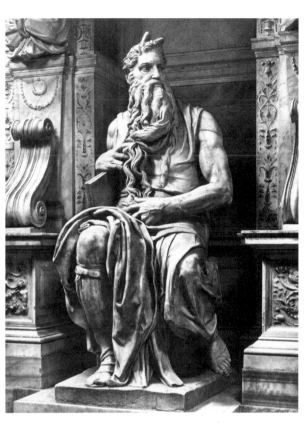

16. Michelangelo, *Moses*

The "tragedy of the tomb" was not, however, destined for conclusion, because the new pope Leo X (Giovanni de' Medici, son of Lorenzo the Magnificent) called Buonarroti back to Florence to charge him with designing the facade of the basilica of San Lorenzo, which had been left unfinished by Brunelleschi. For three years, Michelangelo worked on various designs, settling upon the realization of a model that revolutionized the traditional concept of a facade. Ignoring the pre-existing structure, he imagined a plastic body in which architectonic structure and sculptural decoration constituted an indissoluble unity characterized by strong volumetric and luminous contrasts (fig. 17).

Yet once again, however, the work was not completed. The pope abandoned the project for financial reasons and proceeded with the construction of only one chapel, mirroring the Sacristy of Brunelleschi, that was destined to house the tombs of the Magnificent, his brother Giuliano, and two dukes who had recently died. Michelangelo took the Old Sacristy as an example, accentuating the dynamic tension of the framework and its verticality. He envisioned twin funerary monuments, placed in the walls flanking the altar, to hold the sepulchres of Lorenzo, Duke of Urbino (fig. 18), and Giuliano, Duke of Nemours (fig. 19). Beneath the statues of the two 'Captains,' ensconced on the sarcophagi, the personifications of Time found their places: *Dawn, Dusk, Day,* and *Night.* At the base, there were to have been river deities, for which Michelangelo only made the models (fig. 20). On the end wall he put the tomb of the Magnificent and his brother Giuliano, with the statues of the *Madonna and Child* (fig. 21) and the patron saints of the Medici *St. Cosmas* and *St. Damian*, which were sculpted respectively by Giovanni Angelo Montorsoli and Raffaello da Montelupo. In 1524, Clement VII also gave Michelangelo a commission to design a library to be built in the San Lorenzo complex to house the valuable volumes collected by his ancestors (fig. 22).

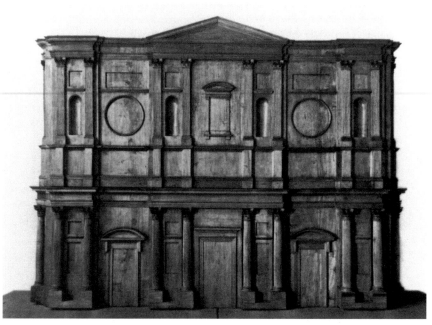

17. Michelangelo, *Wooden Model for the Façade of San Lorenzo*

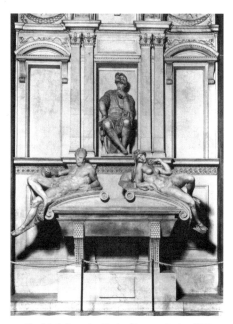

18. Michelangelo, *Tomb of Lorenzo, Duke of Urbino*

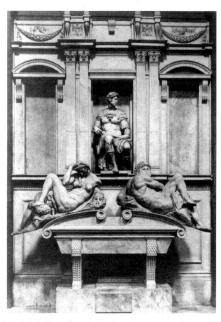

19. Michelangelo, *Tomb of Giuliano, Duke of Nemours*

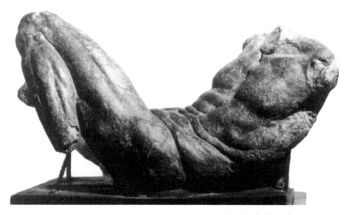

20. Michelangelo, *River God*

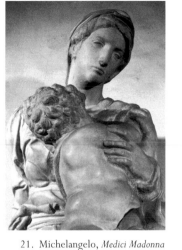

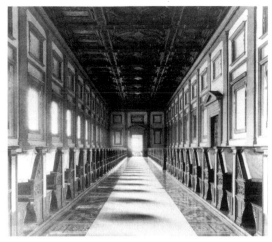

21. Michelangelo, *Medici Madonna* 22. Michelangelo, *Reading Room of the Medici Laurentian Library*

In spite of these weighty burdens, Michelangelo managed to dedicate himself to other projects, such as the design of the "kneeling windows" for the Medici palace and the statue of the *Risen Christ* (fig. 23), which he made for the Roman church of Santa Maria sopra Minerva. Michelangelo signed the contract with his patrons Bernardo Cenci, Mario Scappucci, and Metello Vari in June 1512, pledging that he would deliver the statue within four years. Nevertheless, after two years of labor, on account of a flaw in the marble, he abandoned the work and began to sculpt a new version of the statue, which, when it was all but complete, was sent in the spring of 1521 to Rome, where it was given finishing touches and installed by Pietro Urbano.

In 1527, after the Sack of Rome, the Medici were chased out of Florence and a republican regime was established. Michelangelo, having left the work at San Lorenzo, was loyal to the new government, for which he took up work again on the group to be placed as a pendant to *David*, which had been commissioned twenty years earlier by Soderini's republic. The group, which the artist reconceived from *Hercules and Cacus* to *Samson and a Philistine* was quickly abandoned because Michelangelo was elected to the Committee of Nine on Military Affairs (i Nove della Milizia) and charged with putting in place a system of fortifications for the city, which was already then beseiged by imperial troops. This duty also led him to the court of Alfonso I d'Este in Ferrara, where he studied the city's defensive systems and where he received the commission for a painting representing *Leda and the*

Swan, inspired by antiquity both for its subject and iconography. The work, however, never entered the Este collections and was sold to the French sovereign Francis I by Antonio Mini, who had received it as a gift from his master. Despairing the fate of the Florentine republic, Michelangelo left the city on September 21, 1529 to take refuge in France at the court of Francis I. The journey was interrupted, however, in Venice, and at the end of the year Michelangelo returned to Florence and resumed his work. But the Florentine republic was counting its days, and in August of the following year the Medici returned to Florence. During this time, Michelangelo sculpted an *Apollo* for Baccio Valori, today in the Bargello museum in Florence, and, after obtaining a pardon from Clement VII, returned to the tasks of the Sacristy and the Laurentian Library.

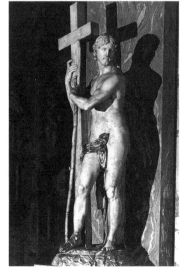

23. Michelangelo, *Risen Christ*

He also renewed contact with the heirs of Julius II, which in April 1532 resulted in a new contract (the fourth, after those of 1505, 1513, and 1516) and a new project for the tomb, no longer to be realized in the Vatican basilica but in San Pietro in Vincoli. The monument, which by now had lost its three-dimensional structure in favor of a wall tomb configuration, was to include eleven statues, six by Michelangelo and five by other artists, not counting the four *Prisoners* now in the Galleria dell'Accademia in Florence (fig. 24) which remained unfinished, and the *Victory* in the Palazzo Vecchio (fig. 25). The artist simultaneously supervised both workshops, dividing his time in the years 1532-34 between Florence and Rome. Also dating to these years is the elaboration of the "cartoons" of either religious or mythological subjects whose painted realization was entrusted to Sebastiano del Piombo or Pontormo.

It was perhaps for Clement VII's massive project to have him fresco the altar wall of the Sistine Chapel with the *Last Judgment* (fig. 26), or perhaps for the friendship that bound him to the young Tommaso dei Cavalieri, whom he met in 1532, that in September 1534 Michelangelo moved permanently to Rome, where he attended to the work for the tomb of Julius II and the *Last Judgment*, leaving the New Sacristy to be completed by other artists according to the models he provided them. To complete the *Last Judgment*, Michelangelo returned to work in the Sistine Chapel after almost forty years. During this time his art had lost the classical harmony that characterized his paintings for the ceiling, becoming, in this fresco, an apolocalyptic vision in which no harmonius or rational laws exist, but where instead the whole surface, deprived of depth, is animated by the swirling movement of figures with robust bodies and contorted faces.

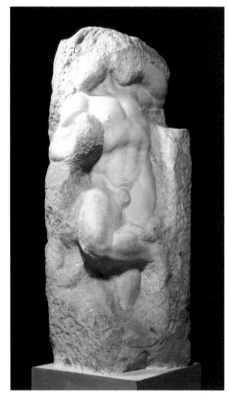

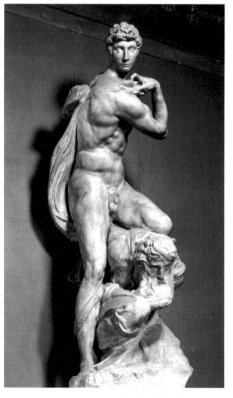

24. Michelangelo, *Slave*

25. Michelangelo, *Victory*

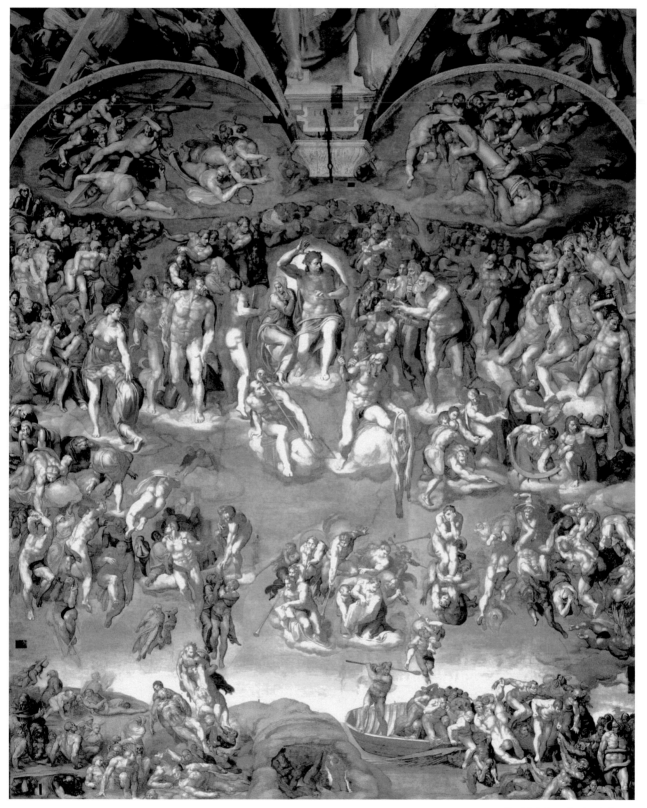

26. Michelangelo, *Last Judgment*

Clement VII was succeeded by the Farnese pope Paul III, who confirmed Michelangelo's commission for the *Last Judgment* while freeing him from any obligation to the heirs of Julius II. The pope then named him "chief architect, sculptor, and painter of the Apostolic Palaces" and entrusted him with the urbanistic planning of the Capitoline square. In the center of the piazza, he placed the equestrian statue of *Marcus Aurelius* (fig. 27) and then designed the monumental stairway, the senatorial palace, and conservators' palace, whose construction Tommaso dei Cavalieri supervised as a deputy to the construction of the Capitoline. Upon the death of Antonio da Sangallo il Giovane (1546), Michelangelo became responsible for the completion of the Farnese Palace. His intervention in the facade and courtyard, while respecting what was already there, gave the building a plastic dynamism. He was also named architect for the construction of St. Peter's, for which he abandoned Sangallo's plan, which had combined the model of a central layout with a longitudinal one, and returned to Bramante's idea of a central layout with a Greek cross inscribed in a square. He designed the apses and the dome, and conferred unity upon the exterior through a gigantic order of Corinthian pilasters, upon which rests an attic running around the entire building.

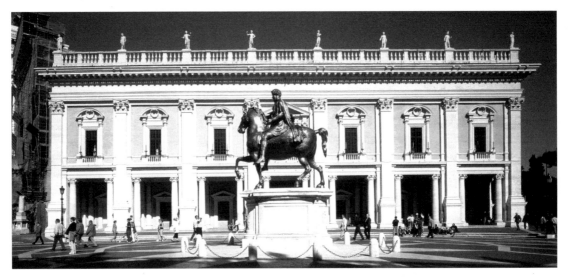

27. Michelangelo, *Capitoline Square*

During the pontificate of Paul III the "tragedy of the tomb" finally ended. Thanks to the intervention of the pope, a new contract was signed (August 20, 1542) that called for the completion of the monument to Julius II with the statues that Michelangelo had already finished (the *Moses* and the Louvre *Prisoners*, later substituted by the statues of *Rachel* and *Leah*) along with three others (the *Madonna and Child*, a *Prophet* and a *Sybil*) sculpted under his direction by Raffaello da Montelupo. While he was painting the fresco of the *Last Judgment*, Michelangelo created a marble bust of *Brutus* (fig. 28) for the Florentine exile Niccolò Ridolfi, who in his pride incarnated the republican ideals of the artist and his position with respect to the Florentine political situation.

28. Michelangelo, *Brutus*

With the Sistine frescoes unveiled in 1541 and the final contract signed with Julius's heirs, Paul III asked Michelangelo to create frescoes of the *Conversion of St. Paul* (fig. 29) and the *Crucifixion of St. Peter* (fig. 30) for the Pauline Chapel. Even more than the *Last Judgment*, these frescoes demonstrate the profound rift in the artist's conscience, which was disturbed by the events that had overwhelmed the Church in those years. Contributing to Buonarroti's movement toward a reformist position was Roman poetess Vittoria Colonna, with whom Michelangelo held a deep friendship and for whom he created a few works with religious subjects.

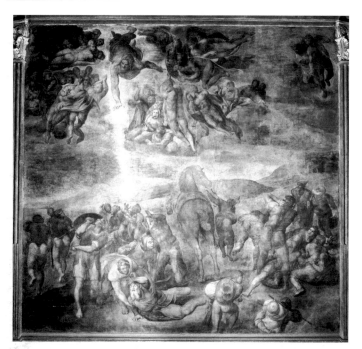

29. Michelangelo, *Conversion of St. Paul*

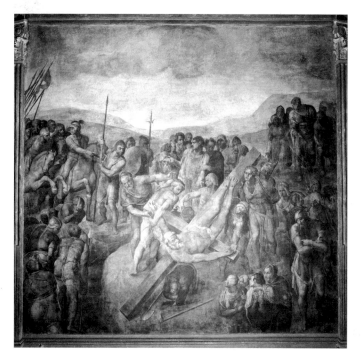

30. Michelangelo, *Crucifixion of St. Peter*

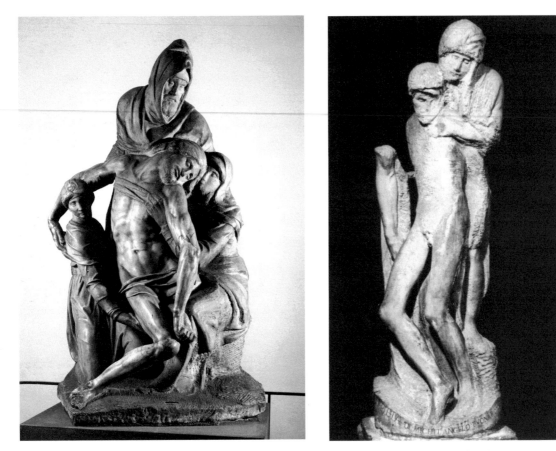

31. Michelangelo, *Florence Pietà* 32. Michelangelo, *Rondanini Pietà*

The artist's decision to sculpt a *Pietà* for his own tomb should also be seen in this same perspective. During the latter part of his life, in fact, Michelangelo applied himself less and less to painting and sculpture in order to concentrate on his architectural studies. His last two sculptures are two versions of the *Pietà*: the first, today in the Museo dell'Opera del Duomo in Florence (fig. 31), already begun in 1550, was almost finished when a crack was noticed that induced Michelangelo to mutilate the block and abandon it. The sculpture was sold to Francesco Badini, who had it finished by Tibero Calcagni, a student of Buonarroti. Michelangelo continued to work on the second version (Milan, Castello Sforzesco, fig. 32), begun in these years, until his death, though he was never satisfied with the results he achieved. Indeed, only death interrupted Michelangelo's incessant searching: he changed the position of Christ and his Mother several times, reaching a point of extreme essentialism and intense dramaticism.

The duty of architect for the construction of St. Peter's was confirmed by the successors to Paul III. For Buonarroti, the completion of the basilica represented a kind of expiation for sins. He asked that the contract expressly state that "he was serving the construction for the love of God without any reward" and in response to requests by Cosimo I de' Medici to return to Florence he replied that to abandon the labor would be "the cause of great ruin to the construction of St. Peter's, a great shame, and a very great sin." Although the duke did not succeed in bringing Michelangelo back to Florence, he obtained from him a commitment to design the church of the Florentine community in Rome (fig. 33). Around 1559-60, Buonarroti worked up several designs featuring a central layout imposed on the form of a circle or square and animated by a strong dynamic tension. The central layout motif was also evident in the Sforza Chapel in Santa Maria Maggiore, the design of which

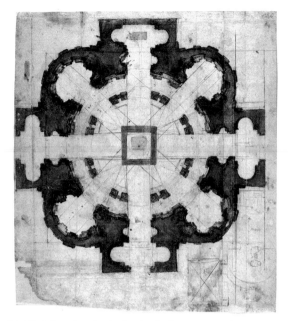

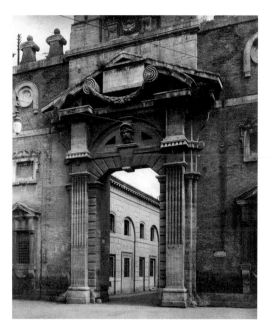

33. Michelangelo, *Plan for the Church of San Giovanni dei Fiorentini*

34. Michelangelo, *Porta Pia*

dates to around 1560. The last years of the artist's life also witnessed the completion of designs for the Porta Pia (fig. 34), commissioned by Pope Paul IV as a scenographic finish to the new street that he had opened between the Quirinale and the Aurelian walls. Michelangelo's architectural activities ended with the transformation of the Baths of Diocletian into the church of Santa Maria degli Angeli.

On February 18, 1564, at nearly ninety years of age, Michelangelo died at his house (the Macel de' Corvi, Rome) in the company of his dearest friends, among them Tommaso dei Cavalieri and Daniele da Volterra. Just one month earlier, the congregration of the Council of Trent had decreed that the parts of the *Last Judgment* regarded as obscene be covered over, a gesture that showed the most complete misunderstanding not only for Michelangelo's art but also for his intense spirituality.

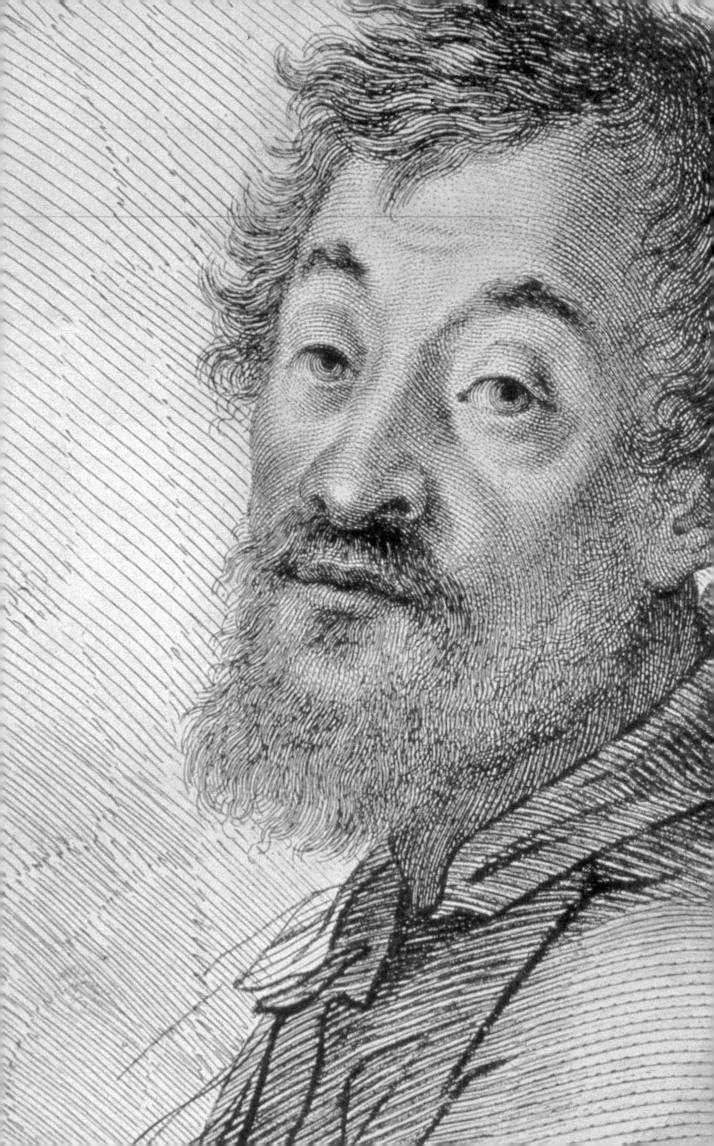

THE FACE OF
MICHELANGELO

As we shall see, this portion of the exhibit addresses a topic rarely examined by scholarship. No doubt there is more here to present than to summarize. Interest in the subject is natural for those who, working at Casa Buonarroti and thus unavoidably in the shadow of Michelangelo, can see as many as four life portraits of the master: those painted by Giuliano Bugiardini and Jacopino del Conte, the medal executed by Leone Leoni (included in this exhibit), and the bust by Daniele da Volterra. And yet the Michelangelo literature contains few references to our topic. As we will discover, this situation is likely due to the artist's aversion to painting himself and being portrayed by others.

Vasari writes: "Of Michelangelo there are no other portraits than two paintings, one by the hand of Bugiardino [Giuliano Bugiardini] and the other by Jacopo del Conte [Jacopino del Conte], one in three-dimensional bronze executed by Daniello Ricciarelli [Daniele da Volterra], and this (namely, the famous medal) by the Cavalier Leone [Leone Leoni], from which many copies have been made, which I have seen in great numbers in many places in Italy and beyond." Only a few additions can be made to Vasari's brief listing. Among these, the watercolor by Francisco de Hollanda stands out. It is a singularly domestic image of Michelangelo at more than sixty years old, bringing to mind the conversations at San Silvestro that Vittoria Colonna presided over and which the then twenty-one-year-old Portuguese artist partially transcribed. This portrait appears in an album of fifty-four sheets by Francisco, conserved in the library of the Escorial. The album was well known even before the publication in Spain in 1863 of the watercolor that included the portrait of Michelangelo in the second volume of *El arte in España. Revista de las artes del dibujo.* Two biographers of Michelangelo from the second half the nineteenth century, Aurelio Gotti and Gaetano Milanesi (who took up the subject in 1875 on the occasion of the celebration of the four hundredth anniversary of the birth of Michelangelo), seem to have been ignorant of its existence. On the other hand, Herman Grimm knew about it, for in his historical biography of the artist (1860-1863) he goes on for pages about Francisco and the conversations at San Silvestro. Francisco de Hollanda's portrait shows Michelangelo wearing a hat with a narrow brim, evidently like one he used to wear. This clothing accessory marks the beginning of an entire series of portraits and engravings that is surely based on the prototype by Jacopino, but which include a head cloth similar to the one that appears in the watercolor by the Portuguese artist.

One could argue that other images of Michelangelo are derived from prototypes referred to here, the vast majority from the four mentioned by Vasari. Approximately one hundred sixteenth-century engravings and portraits, numerous on account of Michelangelo's fame, were listed by Ernst Steinmann, the scholar who, at the beginning of the second decade of the twentieth century,

Daniele da Volterra, *Bust of Michelangelo*

Francesco Bartolozzi, detail, *Portrait of Michelangelo*

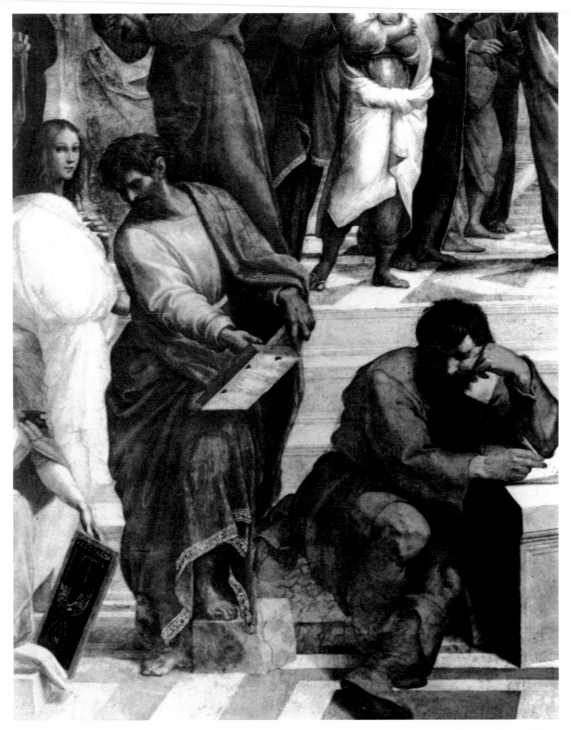

Raphael, detail, *School of Athens*

courageously probed the depths of the subject with scientific seriousness and for the most part firsthand, concluding with the images from the early seventeenth century in the "Galleria" of the Casa Buonarotti. Meritorious among students of Michelangelo to a degree that we need not repeat here (see cat. 12), the German art historian became involved in the 1911 celebrations of the fiftieth anniversary of the unification of Italy. It was a crucial year for the nation, remembered primarily for the invasion of Libya that the Italian government carried on despite widespread hostility abroad and the opinions of those inside the country, who, like Gaetano Salvemini, judged the attack on Libya as nothing less than a damaging "snare." Meanwhile, the inspiration of Gabriele D'Annunzio was dangerously exalting the *Canzoni della gesta d'oltremare*, another surely more innocuous thread of homemade nationalism, preparing to celebrate the semi-centenary. There were events throughout Italy. In the capital, Rome, the great international Exposition was held at Valle Giulia, and many other projects flourished under its shadow, among them, at Castel Sant'Angelo, the so-called "retrospective exhibitions." Steinmann collaborated on the first and, until 2008 with an exhibition at Casa Buonarroti, the only exhibition of portraits of Michelangelo. Steinmann developed an expertise over many years that culminated in his monumental work on the subject published in 1913.

It is a peculiar coincidence that the two principal contributions to the bibliography on the topic both date back to the same year. In January 1913, Paul Garnault handed off the proofs for his *Les Portraits de Michelange*, a very informed work by a connoisseur with a passion for the Italian cities of art. In it he cites Steinmann only in what he wrote before 1911, arriving, nevertheless, at similar conclusions: "If one takes account of the late images, which are purely imaginary, or those that were inspired by simple reminiscences, the number of known portraits of Michelangelo, genuine or supposed, reaches nearly a hundred. Amid this vast bric-à-brac, there are only five true portraits, which is to say poses …."

Yet the image of Michelangelo comes down to us also from another form of portraiture: just as with many great persons, and not only those from the history of art, his physiognomy was in fact reproduced by artists who were his contemporaries and who conferred it upon characters portrayed in group scenes. Of these there are many examples, among them we recall the work by Raphael in the Stanza della Segnatura in the Vatican; by Giorgio Vasari in the Salone dei Cento Giorni in the Palazzo della Cancelleria in Rome and in the Sala di Leone X in the Palazzo Vecchio in Florence; by Alessandro Allori in the Montauti Chapel in the church of the Santissima Annunziata in Florence and by Daniele da Volterra, who gave the features of his great friend to an apostle in the fresco of the Assumption of the Virgin in the Della Rovere Chapel in the church of the Trinità dei Monti in Rome. For this last portrait, the famous preparatory cartoon still exists, preserved in the collections of the Teylers Museum in Haarlem—a lively and intense image, evidently taken from life.

Contemporaneous with the Master, and as a result of his reputation, are also those images that lie between anecdote and imagination. A rare engraving, of which a copy can be traced in the British Museum, shows the artist in meditation. Along its bottom edge, an inscription reveals the artist's intention to harken back to Michelangelo when he was twenty-three years old, during his first Roman sojourn while he was working on the Vatican Pietà. In 1527, Sigismondo Fanti portrayed "Michael the Florentine" sculpting—half naked and with great fervor—a female statue in which, at the time of Steinmann, people wanted to see the "Dawn" of the New Sacristy. And after the death

of the Master, in the early 1580s, Federico Zuccari, in a pleasing painting in the Galleria Nazionale d'Arte Antica in the Palazzo Barberini in Rome, depicted Michelangelo on horseback observing Zuccari's brother Taddeo painting the facade of Palazzo Mattei.

Likewise our treatment of the subject ends with the contemporaries of the Master. Yet in the catalog of an exhibition comprising works exclusively from the Casa Buonarroti, one cannot neglect the room of the museum called the "Galleria," in which Michelangelo's grand nephew assembled a tribute to his great ancestor approximately fifty years after his death composed of paintings commissioned from the most prominent artists who were active in Florence during the first part of the seventeenth century—the face of the Master always referring back to prototypes, especially the portrait by Jacopino.

It is known that Michelangelo portrayed himself very rarely. A much deteriorated drawing in the Louvre, which appears to depict a not-so-young Michelangelo with a "turban," was discovered by Steinmann, who believed it was a self portrait, an hypothesis picked up by Berenson in 1938, subsequently accepted by Tolnay, and then by Michael Hirst in 1988. Recently, Paul Joannides has attributed the drawing to Baccio Bandinelli. Without a doubt, Michelangelo portrayed himself in the head incorporated in the flayed skin of Saint Bartholomew in the "Last Judgment" in the Sistine Chapel, which continues to intrigue psychoanalysts. But it was impressed in a still more emotional way in the features on the serene face, beyond all suffering, of Nicodemus in the "Pietà" in the Museum of the Opera del Duomo in Florence. "Messer Tommaso [Cavalieri] drew Michelangelo in a lifesized cartoon, of whom no one either earlier or later made a portrait, because he abhorred making something resemble life if it were not of infinite beauty." Thus writes Vasari, and the two examples of self portraiture cited above are not enough to contradict him, nor the destroyed bronze statue of Julius II, nor the lost portrait of the most handsome Tommaso, nor the effigies of Pietro Aretino or Biagio da Cesena which are recognized in that pitiless fresco of eternal salvation and damnation that it is the "Last Judgment." Nevertheless, the reluctance of the artist to portray others and himself remains proverbial. In fact, the two oldest biographers preferred to portray Buonarroti by transmitting his features in writing. Condivi (1553) mixed physical characteristics with tendencies, habits, and thoughts, while Vasari, in the Giunti edition of 1568, copied without remorse the description of his colleague, even down to the particulars of certain flecks in Michelangelo's eyes that were between gold and blue.

In the introduction to his work on the portraits of Michelangelo, Steinmann asks himself, "Why did Tiziano paint a portrait of Aretino and not one of Michelangelo? Why in the golden age of modern art did no brush or chisel create a truly great image of the greatest of all masters? Even if opinions about the names of the artists who attempted to portray Michelangelo have been so discordant, and despite the discounting of the quality of these works, the general consensus is that nevertheless the great Buonarroti was never represented in a manner that corresponded to the heights of artistic practice of that era, nor of his own greatness. Every artist depicts himself in the best way, Michelangelo once affirmed, but he never turned the truth of this pronouncement upon himself." Steinmann continues: "Michelangelo pushed the ardor of friendship to express itself more willingly with the pen than with the brush or chisel. What is more, while he sketched a design for a funeral monument for the prematurely deceased Cecchino Bracci, and supervised the execution of the monument, yet he nevertheless composed not less than fifty epigrams in order to console his friend Luigi del Riccio on the loss of his favored one. When Gandolfo Porrino begged him to restore

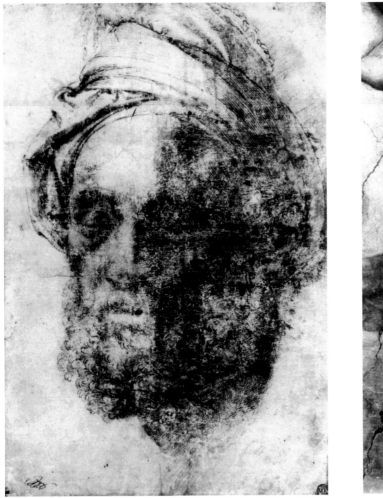

Baccio Bandinelli, *Portrait of Michelangelo* Michelangelo, detail, *The Last Judgment*

joy and peace to his eyes, and to preserve with brush or chisel the features of the beloved who had been precociously torn away from him, Michelangelo composed an epigram for the monument of the departed but refused the petition for a portrait."

It is with a conviction quite close to these affirmations of the German scholar that we attempt, at the end of this section of our exhibition, to trace a sort of "interior" portrait from references and the autographical presence of Michelangelo as poet and writer. Next to Steinmann's large volume, one will notice a poem written in the Master's hand and a few editions of his poems, from the one edited in 1623 by his grand-nephew (profoundly revised, with misleading corrections that reflect the moralistic concerns of the time) to the one published by Karl Frey with critical rigor in 1897.

The immeasurable stature of Michelangelo in the historical panorama of artists has obscured his poetic gifts during the intervening centuries. While he was alive, his verses naturally contributed to his myth. They were beloved and exalted, not only by his closest associates, for their fame had already gone beyond that restricted circle. Some of them, notwithstanding the objective difficulty of their rhymes, were set to music. The praises for this genius, which lacked not "the ornament of

sweet poetry" (Vasari), were overabundant: enflamed and erudite was the admiration of Donato Giannotti and Benedetto Varchi, who took the argument for one of his lectures for the Florentine Academy in 1547 from one of Michelangelo's sonnets that is still celebrated today, "Non ha l'ottimo artista alcun concetto" ("The best artist does not have any conception"). Next we come to the excessive hyperbole of Pietro Aretino, who, before the historical divergence between the two, wished to place the writings of Michelangelo in the emerald jar in which Alexander the Great enshrined the poems of Homer. Francesco Berni meanwhile contrasted the rhymes of Michelangelo with the excessive languor of his contemporary Petrarchists:

> *Ho visto qualche sua composizione,*
> *sono ignorante, e pur direi d'avelle*
> *lette tutte nel mezzo di Platone.*
> *Sì ch'egli è nuovo Apollo e nuovo Apelle.*
> *Tacete unquanco, pallide viole*
> *e liquidi cristalli e fere snelle:*
> *e' dice cose e voi dite parole.*

<div align="right">

I saw some of his compositions,
I am ignorant, and yet I would say that I had
read them all in Plato.
Indeed, he is a new Apollo and a new Apelles.
Keep steadily silent, pale violets
and liquid crystals and skinny animals:
he says things and you say words.

</div>

On the other hand, the comparison between painting and poetry, which remained a lively topic of debate throughout the 1500s, had consecrated, even from this point of view, the universality of Michelangelo, who, for his part, shied away from unexpected praise. This is seen in his own correspondence, on which Condivi faithfully commented: "But for this [composing poetry] he did it more for his enjoyment than as a profession, always humbling himself and acknowledging his ignorance in such matters."

The Neoclassicists were the first to compare the poetry of Buonarroti to his figurative work. Yet a true and proper critical reflection on Michelangelo the poet began, as is commonly recognized today, with a great Italian poet, Ugo Foscolo. In the course of his dramatic later years in London, twice, in 1822 and 1826, Foscolo turned to this theme, relating it perhaps too firmly to his classicist ideals. He was resolute in not considering Michelangelo's rhymes to be "the products of a man professing poetry" (terms that recall those of the early biographer!), yet still appreciating in his verses "a certain original and uncommon quality that, separating them from every vulgar thing, made them valuable and admirable."

The rhymes were studied and translated into the principal European languages, even by poets on the level of Wordsworth and Rilke, and were often celebrated throughout the nineteenth century, when scholars from Guasti to Frey began to occupy themselves with Michelangelo the poet

with proper philological fervor, despite the silence of Francesco De Sanctis. In the course of the twentieth century, the appraisal was more severe, beginning with Benedetto Croce's negations. Yet the accusation of dilettantism and literary inexperience must have fallen fatally, as, for example, the convincing youthful readings of Gianfranco Contini seem to demonstrate, or the declamatory yet happy intuitions of Giovanni Papini on the poetry of Michelangelo as the essential moment for his spiritual development.

Nevertheless, a stylistic definition of his poetry remains difficult and not altogether clarified. We can repeat, with Luigi Baldacci, that:

> …when it does not consist of manneristic eccentricities or spiritual rhymes, the poetry of Michelangelo is inspired by love and refers for the most part to his most significant relationships—on the one hand, his relationship to the young Roman Tommaso Cavalieri, whom the poet met around 1532 and about whose extraordinary beauty and gracefulness of manners and mind contemporaries witnessed, and, on the other hand, with Vittoria Colonna, which began later and whose echo endured after her death in 1547.

We can also agree with this great Italian critic when he acutely contrasts Vittoria's Platonism (which today can seem frankly frigid) to that heroic furor that in Michelangelo is "the sign of an immense spiritual ordeal placated only in God." Baldacci, however, concludes his investigation by affirming that on the level of poetry, Michelangelo's offerings, at times sublime, remain "more intentional than real."

Besides this assessment, many of the most attentive and sensitive readers of our time have persuaded us to discern in the poems of Michelangelo the exigencies of a personal, intimate solace, an outpouring of the soul, pensive and intensely private traces of memory—in sum, expressions of a lofty spirituality that, beyond helping the scholar and biographer, can affect one emotionally even though they remain unexplored in their depths in a marginal, if rather noble, limbo.

We conclude this brief introduction to the reading of Michelangelo the poet with two final statements. In the first place, it does not seem superfluous to underscore that even today his most fervent admirers are those who have studied him for the longest time and with the strongest philological purpose, from the previously cited nineteenth-century pioneers to Enzo Noè Girardi, whose critical edition of the poems of Michelangelo decidedly reflects his experience of more than forty years. Second and lastly, in order to understand the refined meditation and spirituality of these verses, it might help to consider our allusion to the private Michelangelo who gave his friends, more willingly than portraits, his own poetry written in a beautiful hand.

Bibliographic Notes: The Face of Michelangelo

The seminal study on the portraits of Michelangelo is still Ernst Steinmann, *Die Portraitdarstellungen des Michelangelo* (Leipzig, 1913). Most recently see Pina Ragionieri, *Il volto di Michelangelo* (Florence, 2008).

For the portraits of Giuliano Bugiardini and Jacopino del Conte, see Pina Ragionieri in *Michelangelo tra Firenze e Rome* (exhibition catalog), ed. Pina Ragionieri (Florence, 2003), 18-19, 22-23, nn. 1, 3. For the bronze bust

by Daniele da Volterra, see Alessandro Cecchi in *Daniele da Volterra, amico di Michelangelo* (exhibition catalog), ed. Vittoria Romani (Florence, 2003), 170-172, n. 54.

One may read the passage on the portraits of Michelangelo that appears in the Giunti edition of the *Lives of Vasari*, along with the rich commentary by Paola Barocchi, in Giorgio Vasari, *La vita di Michelangelo nelle redazioni del 1550 e del 1568*, ed. Paola Barocchi, 5 vols. (Milan-Naples, 1962), 1:108, 4:1738-43.

For the watercolor by Francisco de Hollanda, which is contained in the codex of the *Antigualhas* (folio 2 recto), see Elia Tormo, *Os Desenhos des Antigualhas que vio Francisco D'Ollanda* (Madrid, 1940), 37-8. This edition offers a complete facsimile of this priceless codex. The relationship between the Portuguese artist and Michelangelo has been examined on several occasions by Sylvie Deswarte-Rosa ("Opus Micaelis angeli. Le dessin de Michel-Ange de la collection de Francisco de Holanda," in *Prospettiva*, 53-56 (1988-1989), 388-98; "'Idea' et le Temple de la Peinture. I. Michelangelo Buonarroti et Francisco de Holanda," in *Revue de l'Art*, 92 (1991), 20-41; "Vittoria Colonna und Michelangelo in San Silvestro al Quirinale nach den 'Gesprächen' des Francisco de Holanda," in *Vittoria Colonna, Dichterin und Muse Michelangelos* (exhibition catalog), ed. Sylvia Ferino-Pagden (Vienna and Milan, 1997), 349-73).

The celebrations of 1911 have been reconstructed in *Roma 1911* (exhibition catalog), ed. Gianna Piantoni (Rome, 1980). An adequate appraisal of the "retrospective exhibitions" is still wanting.

For the portrait of Michelangelo in the garb of the Greek philosopher Heraclitus, which Raphael incorporated into his *School of Athens* as we know by the finished fresco, see Anna Forlani Tempesti, *Raffaello e Michelangelo* (exhibition catalog) (Florence, 1984), 59, n. 64.

For the portraits of Michelangelo in Vasari's cycles in Rome (in the scene with the remuneration of the virtues, in the Sala dei Cento Giorni, 1546, in the Palazzo della Cancelleria) and in Florence (in the scene with Leo X electing the cardinals in the Sala di Leone X, 1555-1562, in the Palazzo Vecchio), see Julian Kliemann in *Giorgio Vasari, Principi, letterati e artisti nelle carte di Giorgio Vasari* (exhibition catalog) (Florence, 1981), 120-3, n. 19 and Ettore Allegri and Alessandro Cecchi, *Palazzo Vecchio e i Medici* (Florence, 1980), 119-20, n.21.

In the large panel of the "Last Judgment" executed for the Montauti chapel now transferred to the Galli chapel in the church of the Santissima Annunziata in Florence (see Simona Lecchini Giovannoni, *Alessandro Allori* [Turin, 1991], 218-9, n. 11), the young Alessandro Allori declares his own devotion to Michelangelo by inserting his portrait, as Filippo Baldinucci first noticed: "Behind the figure of Jesus disputing there are two old men ...; the first is Buonarruoti, and the second, to his left, is Agnolo Bronzino, the uncle and master of the painter" (Filippo Baldinucci, *Notizie dei professori del disegno da Cimabue in qua*, ed. Ferdinando Ranalli, 5 vols. [Florence, 1846], 3: 521).

For Daniele da Volterra's cartoon at the Teylers Museum of Haarlem (inv. A 21), see Ippolita di Majo in *Daniele da Volterra*, op. cit., 110-2, n. 27.

For the illustration of the "Triumph of Fortune" by Sigismondo Fanti, see Pina Ragionieri in *Michelangelo tra Firenze e Roma*, op. cit., 20, 21, n.2.

For the painting of Federico Zuccari, see Lorenza Mochi Onori, in *Michelangelo tra Firenze e Roma*, op. cit., 42, 122-3, nn. 16, 49, and Benedetta Matucci in *Il volto di Michelangelo* (exhibition catalog) (Florence, 2008), n. 32.

The history of the "Galleria" in the Casa Buonarroti is recounted by Adriaan W. Vliegenthart, *La Galleria Buonarroti. Michelangelo e Michelangelo il Giovane* (Florence, 1976).

For the Louvre drawing (inv. 2715) and the debate over its attribution to Michelangelo and Baccio Bandinelli, see Paul Joannides, *Dessins italiens du Musée du Louvre. Michel-Ange. Élèves et copistes* (Paris 2003), 398-400, n. R27.

The self-portrait of Michelangelo that appears in the flayed skin of Saint Bartholomew in the "Last Judgment" in the Sistine Chapel has been the subject of wide debate, beginning with Francesco La Cava, *Il volto di Michelangelo scoperto nel Giudizio finale. Un dramma psicologico in un ritratto simbolico* (Bologna, 1925).

That Michelangelo depicted himself in the clothing of Nicodemus in the "Pietà" today at the Museo dell'Opera del Duomo in Florence is a hypothesis that was first put forth by Vasari in a letter to Leonardo Buonarroti dated 18 March 1564: "Here is an old man who depicted himself" (*Il carteggio indiretto di Michelangelo*, ed. Paola Barocchi, Kathleen Loach Bramanti, and Renzo Ristori, 2 vols. (Florence, 1995), 2:179-183, n. 362). Still significant on this topic are the considerations of Wolfgang Stechow, "Joseph of Arimathea or Nicodemus?" in *Studien zur Toskanischen Kunst. Festschrift für Ludwig Heinrich Heydenreich zum 23. März 1963*, (Munich, 1964), 289-302, and more recently, John T. Paoletti, "The Rondanini 'Pietà': Ambiguity Maintained through the Palimpsest," *Artibus et historiae* 42 (2000), 60-3.

Vasari's passage on the lost portrait by Tommaso Cavalieri may be found in Giorgio Vasari, *La vita*, op. cit., 1:118; cf. *Michelangelo e l'arte classica* (exhibition catalog), ed. Giovanni Agosti and Vincenzo Farinella (Florence, 1987), 97.

For the woodcut that appears in the Giunti edition of the *Lives* of Vasari produced by "Mastro Cristofano," most likely to be identified as Cristoforo Coriolano, see Pina Ragionieri in *Michelangelo e il disegno di architettura* (exhibition catalog), ed. Caroline Elam (Venice, 2006), 162-3, n. 2.

Varchi's lecture on Michelangelo's sonnet, which "he gave publicly in the Accademia Fiorentina on the second Sunday of Lent" in 1547 and which was published by Torrentino in Florence in 1549, can be read, with commentary, in *Scritti d'arte del Cinquecento*, ed. Paola Barocchi, 3 vols. (Milan and Naples, 1973), 2:1322-41.

An excellent anthology of sixteenth-century texts comparing painting and poetry (from Leonardo to Gaurico, Equicola to Speroni, and Varchi to Borghini) is included in *Scritti d'arte del Cinquecento*, op. cit. (Milano and Naples, 1971), 1:221-462.

Foscolo's essays on Michelangelo the poet, "Michelangelo" of 1822 and "Poems of Michel Angelo Buonarroti" from 1826, are included in Ugo Foscolo, *Opere edite e postume*, 10 vols. (Florence, 1940), 1:333-44.

Croce's assessments of Michelangelo as poet are found in *Poesia popolare e poesia d'arte* (Bari 1933), 391-400.

In 1935, Gianfranco Contini gave a lecture in Strasbourg on the poetry of Michelangelo that was published in 1937 with the title, "*Il senso delle cose nella poesia di Michelangelo*," which later appeared in Gianfranco Contini, "Una lettura su Michelangelo," in *Esercizi di lettura* (Turin 1974), 242-58.

Baldacci's thoughts on Michelangelo as poet may be found in Luigi Baldacci, "Lineamenti della poesia di Michelangelo," in *Paragone* 72 (1955), 27-45. The most trustworthy edition of Michelangelo's *Rime* is still the one edited by Enzo Noè Girardi (Bari, 1960), notwithstanding the decidedly critical observations made by Contini in the year it was published. For several years Guglielmo Gorni has been preparing a new critical edition of the Michelangelo's poetry; for now, one may refer to the copious anthology that is included in *Poeti del Cinquecento*, vol. 1, *Poeti lirici, burleschi, satirici e didascalici* (Milan and Naples, 2001). More accessible editions based on Girardi's text that are presently in print include the one edited by Matteo Residori for Oscar Mondadori (Milano, 1998). Residori has also edited with Paolo Grossi the proceedings of a day of studies on *Michelangelo poeta e artista* (Paris, 2005), which contains a series of contributions, including some of philological character.

1. | WORKSHOP OF THE OPIFICIO DELLE PIETRE DURE
Monument to Michelangelo, 1874

alabaster and precious stones, height 57 cm.

Inv. 625

Dreams of greatness and the will to emulate the illustrious example of the transalpine countries forever abandoned, Florence, after its brief glory as the capital of the new kingdom of Italy (1865-70)—an honor subsequently passed to Rome—was left humiliated by the opportunity it had lost and was forced to confront a difficult economic situation. Mostly for these reasons the city looked to the fourth centenary of the birth of Michelangelo (1875) as a chance for redemption, as a way to recapture if nothing else the role of moral and culture capital. The celebrations took place from the 12th to the 14th of September 1875, but the planning had been underway for a long time. Already in May of 1873 a special committee for the festivities had been formed, presided over by the mayor of Florence Ubaldino Peruzzi. The committee, in keeping with the culture of the time, proposed to exhibit in various spaces of the city all of the works of Michelangelo, not only the originals, naturally, but also casts, copies in plaster, and photographs.

The Casa Buonarroti exhibited its extraordinary collection of Michelangelo drawings and was considered one of the important centers of the celebrations. This also led to a few gifts, among them a particularly valuable and distinguished small bust of Michelangelo in white jasper from Volterra that was most likely executed according to the design of Paolo Ricci (Fiesole, 1835-92) by the skilled artisans of the Opificio delle Pietre Dure. The work was exhibited in the large exhibition that was held on the occasion in the Galleria dell'Accademia and then taken to the Casa Buonarroti, where it still remains today, notwithstanding claims which the aforementioned Opificio advanced in 1908 and which in 1971 still worried Charles de Tolnay, as we gather from his correspondence as director of the Casa Buonarroti from 1965 to1981.

Bibliography: Dionisio Brunori, *Giovanni Bastianini e Paolo Ricci scultori fiesolani: cenni biografici,* Florence 1906, p. 39; *Michelangelo nell'Ottocento. Il centenario del 1875,* catalog of the exhibition at Casa Buonarroti, curated by Stefano Corsi, Milan 1994.

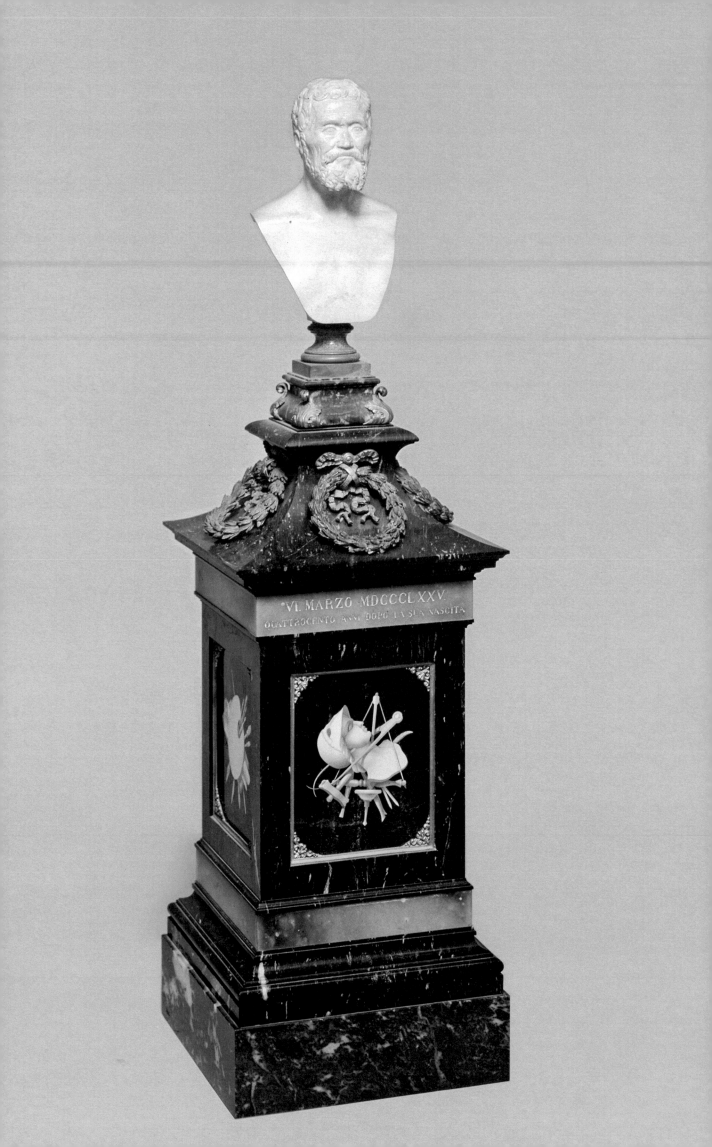

VI MARZO MDCCCLXXV
QUATTROCENTO ANNI DOPO LA SUA NASCITA

2. | MARCELLO VENUSTI (COMO c*1515*-ROME *1579*)
Portrait of Michelangelo, c*1535*

oil on canvas, *36* x *27* cm.

Inv. *188*

In the Casa Buonarroti are exhibited numerous portaits of Michelangelo that came from Florentine galleries in the first half of the twentieth century, all deriving from the same prototype: the famous portrait of the artist executed in Rome around 1535 by the Florentine Jacopino del Conte (1510-98).

The painting exhibited here, attributed to Venusti, also derives from the same prototype, but has for centuries been part of the collections of the Buonarroti family. It is listed, in fact, in an inventory from 1799, which also specifies its location in the seventeenth-century rooms on the first floor of the palace.

The rich baroque frame, the work of seventeenth-century Florentine craftmanship, deserves mention.

Bibliography:

Ernst Steinmann, *Die Portraitdarstellungen des Michelangelo*, Leipzig 1913, pp. 31-32; Ugo Procacci, *La Casa Buonarroti a Firenze*, Milan 1965, pp. 193-194; Georg W. Kamp, *Marcello Venusti. Religiöse Kunst im Umfeld Michelangelos*, Egelsbach 1993.

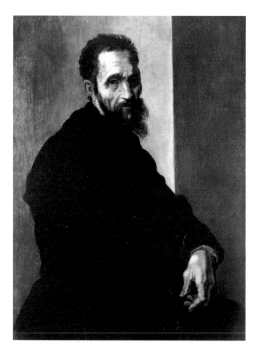

Jacopino del Conte, *Portrait of Michelangelo*

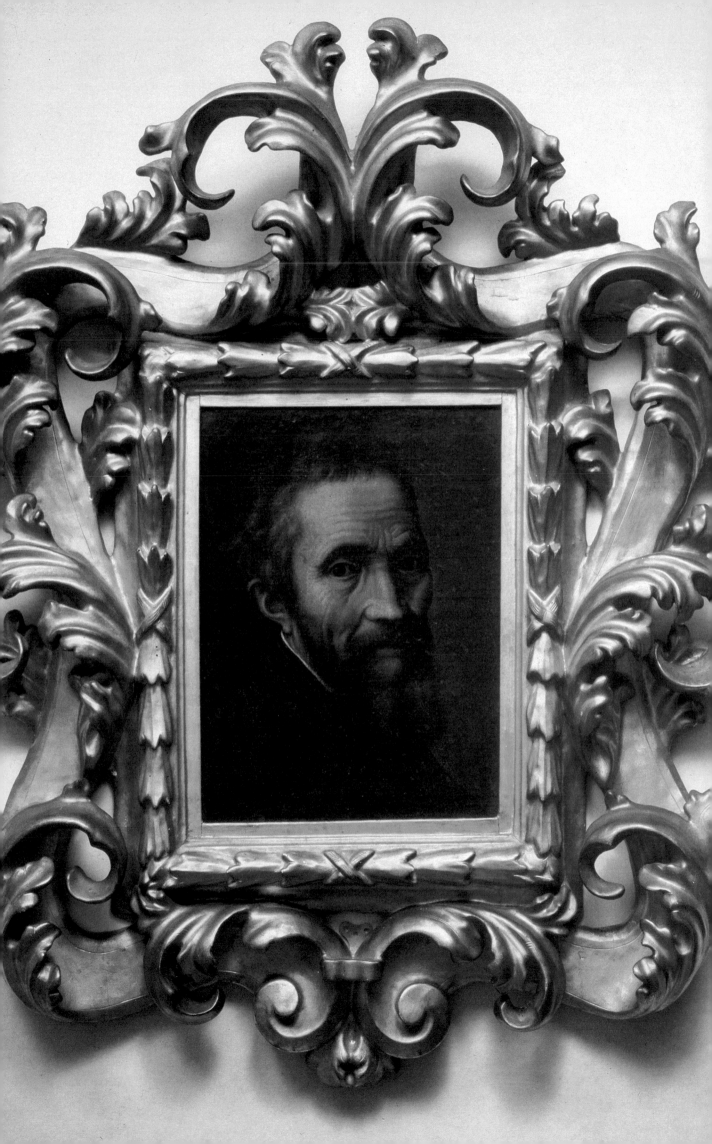

3. | GIORGIO GHISI (MANTUA *1520-1582*)

Portrait of Michelangelo, c*1545-1565*

engraving, *268* x *212* mm.

Inv. *785*

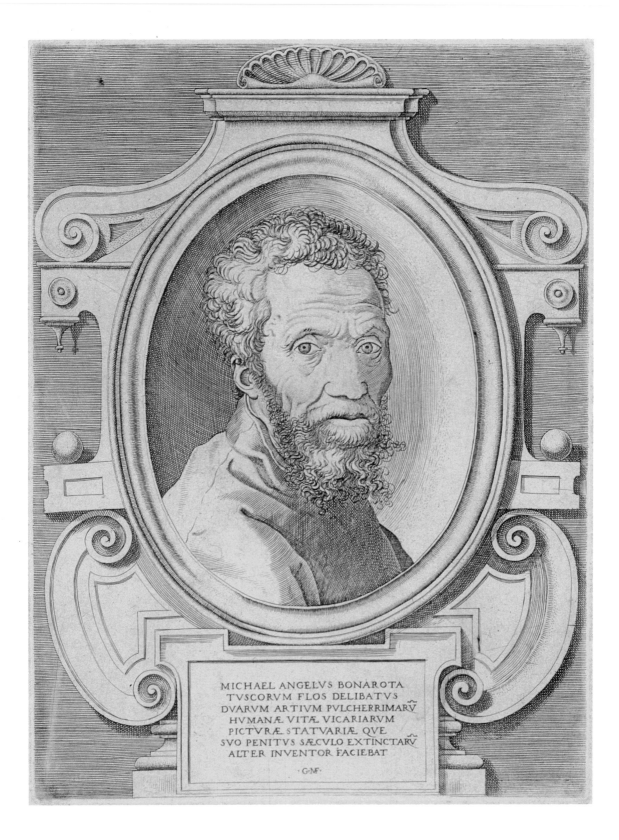

MICHAEL ANGELVS BONAROTA
TVSCORVM FLOS DELIBATVS
DVARVM ARTIVM PVLCHERRIMARŪ
HVMANÆ VITÆ VICARIARVM
PICTVRÆ STATVARIÆ QVE
SVO PENITVS SÆCVLO EXTINCTARŪ
ALTER INVENTOR FACIEBAT
·G·M·

The engraving represents a "Portrait" of Michelangelo inscribed in a Mannerist oval frame among volutes of various styles. This print, cut by Giorgio Ghisi, had in the past been considered the frontispiece of those ten plates, also the work of the Mantuan engraver, that when put together compose the "Last Judgment" of Michelangelo. In reality, the currently accepted opinion is that the "Portrait" originated as a completely independent work and was added to the engravings of the "Judgment" only in a few late editions, such as the one edited by the Calcografia Camerale in Rome, which possesses and still today conserves the copperplates and whose stamp also marks this copy from the Casa Buonarroti.

The portrait of Michelangelo shown here probably derives from a lost drawing, preparatory to the painting by Jacopino del Conte that was executed around 1535. By comparison, the bust engraved by Ghisi, reproduced in the same pose, is more erect and more turned toward the viewer; moreover, the portrait of the artist represents a rather proud Michelangelo—old but not decrepit.

Paolo Bellini, in his monograph dedicated to the Mantuan engraver (1998), dates this engraving to "Ghisi's final stage," in other words, the period in which, having returned from France, he dedicated himself completely to reproductions of the works of the great Italian artists, abandoning altogether and forever the reproduction of works of the Fontainebleau artists. Bellini mantains that the death of Michelangelo, which occured in February 1564, was the event that prompted Ghisi to execute the portrait engraving of the supreme artist.

The engraving would therefore have been born from the desire to commemorate the person of Michelangelo—a hypothesis corroborated, according to Bellini, by the interpretation of the writing beneath the portrait that states that, along with Michelangelo "painting and sculpture disappeared, ending completely with his era." It was therefore a purely celebratory occasion, occurring while Ghisi was still in France, where he lived from around the middle of the 1650s. The "Portrait" would have been engraved beyond the Alps, a theory confirmed among other means by the investigation of the watermark on the first impressions, which can be shown to be "identical to the one used to print the first impressions of the engravings derived from Primaticcio after the frescos in Fontainebleau" (Bellini 1998, p. 211). Although it remains to be explained how Ghisi could have made use, in Paris, of a design utilized for a painting by Jacopino del Conte, we know that the engraved plate arrived in Italy along with its maker to be finished in Rome, where it is still preserved today.

Awaiting confirmation is a further hypothesis of Bellini, who also wants to date to the same commemorative event, namely the death of Michelangelo, the undertaking to reproduce the ten plates of the "Last Judgment." From the point of view of style, Bellini's thesis is supported by Alida Moltedo, who, notwithstanding that she considers both the "Portrait" as well as the "Judgment"—engravings from the end of the 1540s—to be by Ghisi, does not discern between them the qualitative gap noted by other scholars who consider the two groups of works as belonging to two different stylistic stages of the engraver.

[E.L.]

Bibliography: Fabrizio Mancinelli, in *Michelangelo e la Sistina. La tecnica, il restauro, il mito*, catalog of the exhibition, Rome 1990, pp. 247-249, n. 150; Alida Moltedo, in *La Sistina riprodotta*, catalog of the exhibition, Rome 1991, pp. 68-72, n. 17; *L'opera incisa di Giorgio Ghisi*, edited by Paolo Bellini, Bassano del Grappa 1998, pp. 21-26, 210-225.

4. | LEONE LEONI (AREZZO *1509*-MILAN *1590*)
Medal of Michelangelo, 1561

lead, diameter *67* mm.
obverse: MICHAELANGELVS. BONARROTVS. FLO. R. AES. ANN. *88* / LEO
reverse: DOCEBO. INIQVOS. V. T. E. IMPII. AD. TE CONVER
Inv. *611*

On March 14, 1561 Leone Leoni wrote a letter to Michelangelo to accompany his sending four versions, two in silver and two in bronze, of the famous and very beautiful medal that he dedicated to the great artist, which was designed in Rome and executed in Milan. From another letter sent to Michelangelo about a month later, we learn that the author was still waiting, with some consternation, for confirmation of its arrival. A probable witness to the preparatory work for the medal survives in a portrait in pink wax on an oval base of slate, which is preserved in the British Museum. On the reverse there is a cartouche that bears the inscription: "Portrait of Michelangiolo Buonaroti made from life by his friend Leone Aretino."

Together with the medals of Pius IV; Gonzalo de Cordova, duke of Sessa; and Francesco d'Avalos, the marquis of Pescara—all dating to 1561—this marks one of the last attempts of the artist in the art of medal making before he took on the ambitious project of decorating the Escorial complex.

The medal was praised several years later by Vasari, in the Giunti edition of the *Life* of Michelangelo, with these words: "And at that time Cavalier Lione created a very lively portrait of Michelagnolo on a medal and out of kindness to him he fashioned on the reverse a blind man led by a dog [...] and because it pleased him so much, Michelangelo gave him a model of a Hercules crushing Antaeus, made by his hand, in wax, with some of his drawings."

On the obverse the medal displays a bust of Michelangelo, in profile, facing right. Around the border we read an evidently incorrect indication of his age, since Michelangelo was born in 1475. The signature of the artist appears at the base of the bust. The reverse depicts an old blind man, led by a dog, with a tattered old-fashioned vest and the trappings of a pilgrim (a cane, a water skin and a rosary). The physiognomy of the character clearly recalls the traits of Michelangelo, a characteristic noted only rarely in the voluminous bibliography on our medal. The legend around the border is taken from Psalms 51:13.

The debate over the meaning of the representation on the reverse of the medal is still open. We should perhaps accept the least convoluted interpretation, which sees in it the symbol of an earthly pilgrimage. It seems likely that somehow the Master proposed the subject for the reverse to Leone, and that it was consequently suggested that the blindness of the old man with the face of Michelangelo was meant to be understood in a metaphorical sense, an hypothesis that accords well with a few of Michelangelo's poems about old age (take for example the verse "quel ch'altri saggio, me fa cieco e stolto" ["what makes others wise, makes me blind and stupid"]). From other sources, we know that Leone Leoni kept for himself "many verses," as Giovanni Paolo Lomazzo states in his *Idea del tempio della Pittura* (1590).

It is to be noted that the description of the reverse contained in the *Trattato dell'arte de la pittura, scoltura et architettura* (1584) by Lomazzo differs from the examples known today in the details of the tight leash of the dog: "…a medal by a good sculptor, who, on the reverse of medal where he had portrayed Michel Angelo, had made a poor man led by a dog tied by a cord around his neck, which appeared completely taut and straight like a cane, without any sagging. This allowed even a young boy to manage it and to say that if that dog had pulled that cord so strongly either he would strangle himself or he would not be able to turn in any other direction, to the great humor of a few painters who were with me and who were ready to burst out laughing." The episode most likely dates before 1572, the year in which the Milanese painter and portraitist went blind.

The gift that Leone Leoni made to Michelangelo included, as we have seen, four pieces: two in silver and two in bronze. The copy in lead displayed here could not therefore have had the same provenance. Besides, it is not listed in the old inventories of the Casa Buonarroti and is still seldom cited today by specialists. From a technical point of view, one can discern in it an "artist's proof." On the other hand, the existence of sixteenth-century versions in lead is also attested by "fairly large impressions in lead mostly with the images of various famous men" (Michelangelo among them), that were present in the late sixteenth-century collection of Antonio Giganti, a clergyman in the service of prelates and cardinals. Gigliola Fragnito has brought attention to the collection inventory.

Given its extraordinary quality, Pollard believed that the version of the medal in silver, currently preserved in the Museo Nazionale del Bargello in Florence, came into the collections of the Medici as an acquisition from the Buonarroti family.

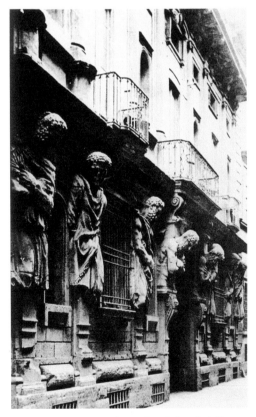

Leone Leoni, *Casa degli Omenoni*

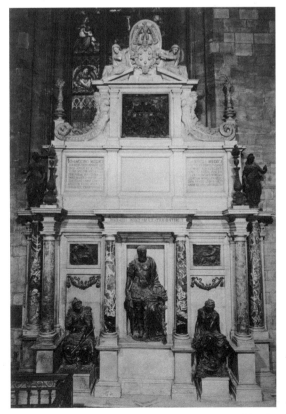

Leone Leoni, *Monument to Gian Giacomo de'Medici*

In the letter of March 15, 1561 Leone Leoni alluded to a papal commission received through the good offices of Michelangelo, a commission that had caused a delay in sending the medals. The letter concerns the tomb for Gian Giacomo dei Medici, the marquis of Marignano, brother of Pius IV, the contract for which was signed on September 12, 1560. The grandiose monument for which, according to Vasari, Leone Leoni used a design given to him by Michelangelo, was placed in the right transept of the Cathedral of Milan where it is still found today. It is one of the principal witnesses to the great fame that Leone Leoni acquired in Milan, which enabled him to build a spectacular home, the so-called Casa degli Omenoni, where Vasari stayed as a guest during his sojourn in Milan in 1566.

In the section of the *Life* dedicated to the artist, Vasari called him "Cavalier Lione, sculptor from Arezzo." Meanwhile, in 1595, a few years after Leoni's death, Paolo Morigia in his book on the noble families of Milan, *La nobiltà di Milano,* affirmed that in reality he came from a family of Arezzo yet was born in Menaggio, in the province of Como. The hypothesis was accepted for a long time, even if with some question, but archival research by Kelley Helmstutler Di Dio has recently demonstrated that the early biographer was correct.

Bibliography: Ernst Steinmann, *Die Portraitdarstellungen des Michelangelo,* Leipzig 1913, pp. 51-52 (with a large bibliography of preceding works); Giorgio Vasari, *La vita di Michelangelo nelle redazioni del 1550 e del 1568,* edited by Paola Barocchi, 5 vols., Milan-Naples 1962, I, p.109; IV, pp. 1735-38; Ugo Procacci, *La Casa Buonarroti a Florence,* Milan 1965, p. 209; Gian Paolo Lomazzo, *Trattato dell'arte de la pittura, scoltura et architettura* (1584), in *Scritti sulle arti,* edited by Roberto Paolo Ciardi, 2 vols., Florence 1973-75, II, p. 162; J. Graham Pollard, *Il medagliere mediceo,* in *Gli Uffizi. Quattro secoli di una galleria,* conference proceedings edited by Paola Barocchi – Giovanna Ragionieri, 2 vols., Florence 1983, I, p. 281; Idem, *Medaglie italiane del Rinascimento nel Museo Nazionale del Bargello,* 3 vols., Florence 1985, III, pp. 1234–36, n. 719; Gigliola Fragnito, *In museo e in villa. Saggi sul Rinascimento perduto,* Venezia 1988, p. 194; Philip Attwood, in *The Currency of Fame: Portrait Medals of the Renaissance,* catalog of the exhibition, edited by Stephen K. Scher, New York 1994, pp. 155–57, n. 52; Marina Cano, in *Los Leoni (1509-1608). Escultores del Renacimiento italiano al servicio de la corte de España,* catalog of the exhibition, edited by Jesús Urrea, Madrid 1994, pp. 190-191, n. 43; Eliana Carrara, *Michelangelo, Leone Leoni ed una stampa di Maarten van Heemskerck,* in "Annali della Scuola Normale Superiore di Pisa", serie IV, Quaderni, 1-2, pp. 219-25; Kelley Helmstutler Di Dio, *Leone Aretino: New Documentary Evidence of Leone Leoni's Birthplace and Training,* in "Mitteilungen des Kunsthistorischen Institutes in Florenz", XLIII, 1999, pp. 645-52; Jeremy Warren, *Renaissance Master Bronzes from the Ashmolean Museum,* Oxford, the Fortnum collection, catalog of the exhibition, London 1999, n. 31; Pina Ragionieri, in *Michelangelo. Grafia e biografia di un genio,* catalog of the exhibition, Milan 2000, p. 83, n. 52; Hugo Chapman, *Michelangelo. Drawings: Closer to the Master,* catalog of the exhibition, London 2005, pp. 263-64, 293, n. 110.

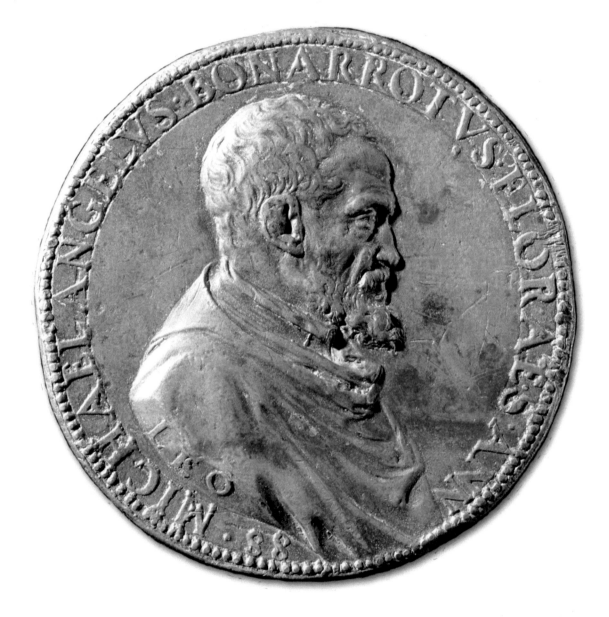

obverse: MICHAELANGELVS. BONARROTVS. FLO. R. AES. ANN. *88* / LEO

reverse: DOCEBO. INIQVOS. V. T. E. IMPII. AD. TE CONVER

5. | MICHELANGELO
Se dal cor lieto divien bello il volto, madrigal, c*1544*

ink, *255* x *183* mm.

Archivio Buonarroti, XIII, *46*

The madrigal is exhibited as an example of a poem of Michelangelo that is not tied to a particular private or personal situation. If one reads and rereads it, the apparent difficulties go away and it reveals itself as one of the many neoplatonic exercises into which this rather unique poet sometimes allowed himself to venture. But this autograph of Michelangelo appears to us also as one of the many examples of that interior "Portrait" that the artist preferred by far to the true and proper depiction of himself (cf. Introduction). It recalls a vein in the poetry of the Master which chronologically more or less goes along with and is sometimes confused with the poems dedicated to Vittoria Colonna. Perhaps inspired by an unhappy experience of love, or maybe just a mere literary exercise, this group of lyrics comes under the name of the "beautiful and cruel," "bitter and feral," "wild," "iniquitous and beautiful," which causes the poet to suffer.

Thus he laments (recalling Ghirardi's paraphrase):

"If the happy heart makes the face beautiful, a sad heart makes it ugly. And if this is the effect that a beautiful and cruel woman produces, who will ever be the one who does not fall in love with me as I do with her? Since by the influence of my guiding star my eyes are made able to distinguish subtly beauty from beauty, she, who often makes me say: 'The ugliness of my face comes from the humiliation of my heart,' acts no less cruelly against herself. Because if by painting a woman, the artist is brought to represent himself in her, how will he paint her if she makes him disconsolate? It would be good for both if he could paint her with a happy heart and a face without tears, because she would appear beautiful and I would not be ugly."

The text from the Buonarroti Archives is rendered exquisitely, having been written on blue paper in beautiful handwriting like that which Michelangelo used for the poems he gave to his friends. The words underneath, "Delle Cose divine se ne parla in campo azzurro" ("Of divine things one speaks on a blue field") can be interpreted as a courtly dedication.

Bibliography: Michelangelo Buonarroti, *Rime,* edited by Enzo Noè Girardi, Bari 1960, p. 92, n. 173, pp. 356-357; *Costanza ed evoluzione nella scrittura di Michelangelo*, catalog of the exhibition curated by Lucilla Bardeschi Ciulich, Florence 1989, pp. 48-51; *Michelangelo. Grafia e biografia*, edited by Lucilla Bardeschi Ciulich and Pina Ragionieri, Florence 2002, p. 71, n. 41.

If by a happy heart the face is made beautiful
and by a sad one ugly; and if a harsh and beautiful woman
can do this, who is she
who burns not for me as I for her?
Since to distinguish well
beauty from beauty
were my eyes made
by my guiding star,
this woman acts against herself
no less cruelly
such that I often say:—on account of my heart her face becomes pallid.—
If one paints himself
when painting a woman, what
then will he do if she makes him unhappy?
Thus it would be good for both
to paint her with a happy heart and a face dry of tears:
she would be beautiful and I not ugly.

Of divine things one speaks on a blue field [i.e., the heavens].

Se dal cor lieto divien ilvolto,
dal tristo il brutto, e se donna aspra e bella
il fa, chi fie ma' quella
che no narda di me co mio di lei.
po ca destiguer molto
dalla mie chiara stella.
da bello abel, fur facti ghochi mei.
Cotra se fa costei,
no men crudel che spesso,
di chi dal cor mie smorto ilvolto viem
che s'altri fa se stesso
pignendo donna i quella
che fara poi se co solato istiem.
duca bo. sarie. bem i narie bem
ritrarla col cor lieto e luiso asciucto
se farie bella, e me no farie bructo

⊙

Delle cose divine sene parla i campo azzurro

6. | MICHELANGELO

*Four epitaphs in honor of Cecchino Bracci sent to
Luigi del Riccio, 1544*

ink, 216 x 230 mm.

Archivio Buonarroti, XIII, 33

*Cecchino has here laid down a noble corpse
in death, such as the sun has never seen the like.
Rome weeps for him, yet heaven gives glory and rejoices
that freed from the mortal coil his soul is happy.*

*Here lies Braccio, and no less than the want
of a tomb for the body, is the need of the sacred rite for the soul.
If more than in life, in death he is worthy to be welcomed
by the earth and in heaven, death for him is sweet and tender.*

*Here death stretched out her arm (Braccio) and picked unripened
the fruit—or rather, the flower of fifteen years yielded.
Only this stone delights in possessing him
while the rest of the world all now weeps.*

*I was mortal Cecchino and now I am divine:
for only a little while had I the world, yet forever heaven will I enjoy
for such a good exchange and for death I am grateful,
because she delivered many dead and me alive.*

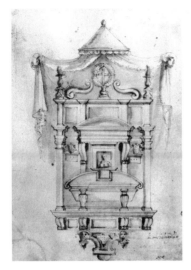

Study of the Tomb of Cecchino Bracci

Cecchino Bracci, the beloved nephew of Luigi del Riccio, died in Rome on January 8, 1544 when he was merely fifteen years old. Michelangelo was bound by a deep affection for the boy, yet it was Luigi del Riccio, the superintendent in Rome of the Strozzi-Ulivieri Bank and during this time a secretary to the artist, who obliged him, with the repeated promise of choice food, to compose over a few months approximately fifty epitaphs (forty-eight quatrains, a madrigal and a sonnet) for this premature death. Once again, upon the commission of Luigi del Riccio, Michelangelo designed Cecchino's tomb, which was built during the course of 1545 in the church of Santa Maria in Aracoeli. A sixteenth-century drawing that reproduces this funeral monument is preserved in Casa Buonarroti.

The sheet on display includes the quatrains reproduced above, while the crosswise annotation reads:

> "Because tonight poetry has been becalmed, I am sending you four sweets (*berlingozzi*) for three finer ones (*berricuocoli*) made by a stingy man. And to you I commend myself, Your Michelangelo who lives at Macello de' [Corvi]."

The famous sketch of a crow takes the place of the name of the Roman street in which the house (now destroyed) where Michelangelo lived was located and jokingly refers to the words addressed to his friend. Concerning these words Cesare Guasti wrote: "*Berlingozzo* (sweet pastry), it seems, was used to indicate something sketchy and rough. Vasari, in a letter, calls his paintings *berlingozzi*: "Those few *berlingozzi* that I make." Michelangelo compares his verses to *berlingozzi*, contrasting them to *berricuocoli*, which are finer pastries. Either he received from Riccio the *berricuocoli* or he uses the word to name other more beautiful verses about Bracci, written by someone who wrote them more parsimoniously than he—perhaps Giannotti and maybe even Riccio, called *cacastecchi* (which means stingy man, worthless) precisely because, by comparison to Michelangelo, he produced only a few and with difficulty."

Bibliography: Cesare Guasti, *Le Rime di Michelangelo Buonarroti, pittore, scultore e architetto*, Florence 1863, p.17; Charles de Tolnay, *L'omaggio a Michelangelo di Albrecht Dürer*, Rome 1972, pp. 11-13; *Costanza ed evoluzione nella scrittura di Michelangelo*, Catalog of the exhibition in Casa Buonarroti, edited by Lucilla Bardeschi Ciulich, Florence 1989, pp. 59-60.

il salma

l nõ vide

si gloria cride

igode lalma

nõ si desia

il sacro usitio

a degnio ospitio

dolce epia

acerbo il fructo

indicanni. Cede

chelpossiede

iage tucto

o

del godo

odo

ri vivo

e che la poesia tanta sta e stata in calma mirando a vostro per fungozzi
pe tre borrino cosi del ca a per chi e a noi mira che mato
vostro amichi oblmace de

104

42 Deposto aqui, ce chi si nob
p morte che l sol ma si mi
roma me piage el cel
che scarca del mortal s

43 Qui giace il braccio e me
sepulcro al corpo a l'alm
se piu che vivo morto
i terra e cel morte gli

44 Qui stese il braccio e col
morte a zil fior caen
sol questo sasso il gode
el resto po del modo il

45 Ifu cechi mortale e or so div
poco ebbil modo e psepre il
disi bel cabio e di morte mi
che molti morti e me part

7. | RIME DI MICHELAGNOLO BUONARROTI, RACCOLTE DA MICHELAGNOLO SUO NIPOTE
(Poetry by Michelangelo Buonarroti, collected by his nephew Michelangelo)

Florence *1623*

Casa Buonarroti, Biblioteca, B.*464*.R.

The fact that the poetry of Michelangelo was handed down over the centuries--not always but neither too rarely as the result of private notes from memory--favored to some degree the legend according to which the artist kept and maintained this activity of his secret and unpublished. On the other hand Michelangelo, beginning in 1544, and particularly in 1546, dedicated himself in Rome, with the help of Luigi del Riccio, the Florentine exile who in those years served as his secretary, to putting order into his poetic production, no doubt with the aim of making it known through printed publication. Riccio died a few months before Vittoria Colonna (1547) and this event, together with the deep sadness for the death of his friend, took the master away from a work which he would no longer be able to take up again. Condivi, on the other hand, finished his biography written as we know almost under the dictation of the Master with a meaningful statement: "I hope before long to make public a few of his sonnets and madrigals, which I have collected over a long time both from him and from others and this in order to make known to the world how much his skill is worth and how many beautiful concepts are born from that divine spirit."

The first edition of the rhymes was nevertheless the one by his grand nephew Michelangelo Buonarroti the Younger, who, in 1623, gave a group of 137 poems by his great ancestor to Giunti for printing. From September to November of 1622 the volume had to be submitted to severe censorship, here recorded in two pages of "licenses," where even the archbishop of Florence bowed to "His Most Reverend Father Inquisitor." As the grand nephew evidently was always anxious to exalt Michelangelo, he had worked for a long time and with the best intentions, consulting the papers of Michelangelo that he had at home and also the papers at the Vatican. Hence, if his edition appears profoundly altered with diverging "corrections" that reflect the moralistic concerns of the time, this happened by the conscious will of the one who produced it. As Cesare Guasti would write 240 years later, Michelangelo the Younger "was thinking of his century, which wanted a completely different kind of poetry, and perhaps worried about damaging the reputation of Michelangelo."

From that time, various editions followed one another. We may cite the one edited by Giovanni Bottari, which was dedicated to the senator Filippo Buonarroti and published in Florence in 1726 by Domenico Maria Manni. It is not dissimilar to the one published by the grandnephew of the author. Meanwhile, the Roman edition of 1817, edited by the erudite Marchigiano Alessandro Maggiori, consciously makes use of the manuscripts of Michelangelo in the Vatican Library. Maggiori thus discovered for the first time the serious distortions contained in the edition of 1623, which he attributed to the use that Michelangelo the Younger made of redactions that differed from those in the Vatican.

It is necessary, however, to move forward to 1862, and the book by Grimm, and, more fully, to 1863 and the work that appeared in Florence, edited by Cesare Guasti for Le Monnier—an edition taken directly from the manuscripts in the Biblioteca Apostolica Vaticana and the Buonarroti

Archives—to come across two important milestones for an understanding of Michelangelo the poet that is correct philologically and also in terms of its content. In particular, we are indebted to Guasti for a work of great value on account of the determination with which he was able to reconstruct an objective legibility for the rhymes of Michelangelo. John Addington Symonds, in his introduction to the first English translation of the sonnets of Michelangelo (cat. 13) praises the clarifying work of "Signor Cesare Guasti," which he had been able to draw upon for his work.

Today we can therefore confidently recognize with Girardi (1960), that the edition of 1623 constitutes "one of the grossest misdeeds that an editor had ever committed to the detriment of a poet, purely with the intention of taking advantage of his fame. The 137 poems that it contains, which were reprinted and constituted the text for more than two centuries, are the outcome of such a radical and systematic manipulation of the material preserved among the Buonarroti manuscripts, that it would never be truly proper to consider them poems by Michelangelo.

Bibliography: Ascanio Condivi, *Vita di Michelagnolo Buonarroti,* curated by Giovanni Nencioni, Florence 1998, p.66; *Le rime di Michelagnolo Buonarroti, pittore, scultore, architetto e poeta fiorentino,* [curated by Alessandro Maggiori], Rome 1817 *passim; Le Rime di Michelagnolo Buonarroti, pittore, scultore e architetto,* curated by Cesare Guasti, Florence 1863, *passim; The Sonnets by Michael Angelo Buonarroti, now for the first time translated into rhymed English by John Addington Symonds,* Venice 1906, p.9; Michelangelo Buonarroti, *Rime,* curated by Enzo Noè Girardi, Bari 1960, p.508.

8. | FILIPPO MORGHEN (FLORENCE *1730*- AFTER *1807*)
GIOVANNI ELIA MORGHEN (FLORENCE *1721* AFTER *1789*)
Based on the design of Joseph Chamant (Haraucourt *1699*-Vienna *1768*)

Tomb of the Great Michel Agnolo Buonarroti
in Santa Croce in Florence, 1746 (?)
engraving, *282* x *198* mm.
in Ascanio Condivi, *Vita di Michelagnolo Buonarroti ...,* second edition,
corrected and enlarged, Florence, Gaetano Albizzini, *1746*
Casa Buonarroti, Biblioteca, B. *738*.R.G.F.

Inscription, on the base:

MICHAELI ANGELO BONAROTIO | E VETVSTA SIMONIORVM FAMILIA | SCVLPTORI. PICTORI. ET ARCHITECTO | FAMA
OMNIBVS NOTISSIMO. | LEONARDVS PATRVO AMANTISS(imo) ET DE SE OPTIME MERITO | TRANSLATIS ROMA EIVS OSSIBVS.
ATQVE IN HOC TEMPLO MAIOR(um) | SVOR(um) SEPVLCRO CONDITIS COHORTANTE SERENISS(imo) COSMO MED(ices) |
MAGNO HETRVRIAE DVCE. P(arandum) C(uravit). ANN(o) SAL(utis) M.D.LXX. | VIXIT ANN(os) LXXXVIII. M(enses) XI.
D(ies) XV.

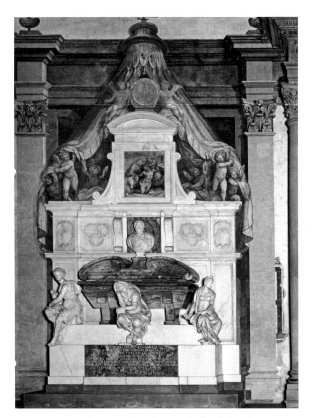

Giorgio Vasari and Vincenzo Borghini, *Tomb of Michelangelo Buonarroti*

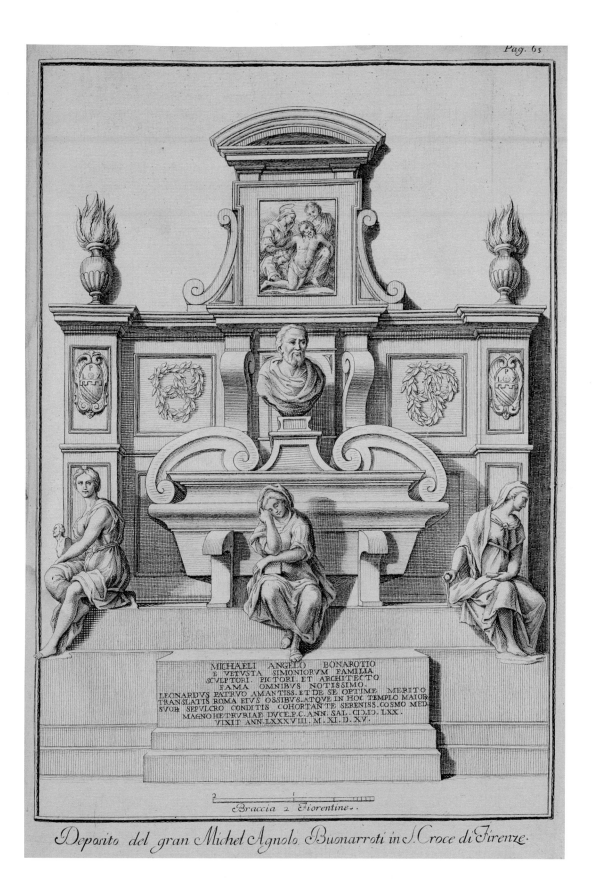

MICHAELI ANGELO BONAROTIO
E VETVSTA SIMONIORVM FAMILIA
SCVLPTORI. PICTORI. ET ARCHITECTO
FAMA OMNIBVS NOTISSIMO.
LEONARDVS PATRVO AMANTISS. ET DE SE OPTIME MERITO
TRANSLATIS ROMA EIVS OSSIBVS. ATQVE IN HOC TEMPLO MAIOR.
SVOR. SEPVLCRO CONDITIS COHORTANTE SERENISS. COSMO MED.
MAGNO HETRVRIAE DVCE. P. C. ANN. SAL. CIƆIƆ. LXX.
VIXIT ANN. LXXXVIII. M. XI. D. XV.

Braccia 2 Fiorentine.

Deposito del gran Michel Agnolo Buonarroti in S. Croce di Firenze.

The engraving of the "Tomb of the Great Michel Agnolo" is one of the plates that illustrates the edition of the *Life of Michelagnolo Buonarroti* by Ascanio Condivi, published in Florence in 1746 and edited by the antiquarian Anton Francesco Gori (Florence 1691-1757). The text, after the revised edtion of the *Lives* of Vasari (1568), became "the rarest book in the bibliography of Michelangelo" (Schlosser, ed. 1956, pp. 374-75). It regained the attention of literary scholars only in the first half of the eighteenth century (ivi, p. 379; Settimo 1975, p. 34), thanks to Gori, who was a central figure in Florentine antiquarianism and a spiritual heir of Filippo Buonarroti (Giannotti 1995, p. 113). It was he who republished the volume with valuable additions like the "Supplement to the life of Michelagnolo Buonarroti" by the sculptor Girolamo Ticciati (Florence 1679-1745), illustrated by the plate with the tomb of Michelangelo. It consisted of a significant addition to the biography of the Master concerning the last ten years of his life up through the funeral on July 14, 1564, which are missing from Condivi's work.

A fraternal friend of Gori, the sculptor boasted the role of an erudite man, as is known, being both a a poet and historiographer. Stefano Corsi has suggested that it is likely that his ties with Filippo Buonarroti might have nourished a devotion to the figure of the Master, as evidenced, for example, by the biography of Michelangelo—another work by Ticciati—for the *Notizie letterarie ed istoriche intorno agli uomini illustri dell'Accademia Fiorentina* [*Literary and Historical Notes About the Illustrious Men of the Florentine Academy*] (Florence 1700). The above-mentioned "Supplement," on the other hand, offered the first opportunity for printing a graphic depiction of the burial. According to what one learns from the preface to the volume, the execution of the drawing and engraving involved many famous artists: Filippo Morghen with his brother Giovanni Elia and Giuseppe Chamant, who, in the guise of an "architect for the theater" and granducal painter, had previously produced an etched illustration of the catafalque that was mounted in 1741 for the Florentine funeral rites for emperor Charles VI (Gori Gandellini 1771, I, p. 267).

The print faithfully reflects the sepulcher suggested by Leonardo Buonarroti and overseen by Giorgio Vasari and Vincenzo Borghini, following the refusal of two initial plans, namely a granducal commission for a monument to be placed in the cathedral, with a bust and epigraphic slab, and a second one also requested by the family from Daniele da Volterra with the integration of unfinished marbles that were left by Michelangelo in via Mozza (Waźbiński 1987; Cecchi 1993). Notwithstanding the absence of graphic evidence of the planning phase—scholars do not in fact recognize as relevant the drawing preserved in Christ Church in Oxford that Steinmann ascribes to Vasari (Steinmann 1913, pp. 76-77; Pope-Hennessy 1964)—it is possible to identify many of the changes that were made to Borghini's iconographic design, according to the will of the same commissioner. Among the most significant changes, one can point to the suppression of the putti covering their faces above and the pilasters carved with the trophies of the Arts as well as the probable substitution of a marble bas-relief depicting the *Pietà* within the central aedicule—in homage to the Bandini *Pietà*—with the fresco of Giovan Battista Naldini, who was also responsible for the canopied crown and the architectonic frame, later restored in the eighteenth century. Instead, the engraving incorporates two architectonic vases on the sides that are no longer present today.

The three sculptures neatly reproduced by Chamant beneath the bust by Battista Lorenzi (Battista Lorenzi for *Painting*, Valerio Cioli for *Sculpture* and Giovanni Bandini for *Architecture*) recall instead the *querelle* (scholarly quarrels) that originated in the environment of the newly born Academy of

Design with regard to the primacy of the Arts. The debate even reached the bier for the funeral in San Lorenzo and was resolved, in the tomb in Santa Croce, with the peremptory placement of the *Sculpture* by Valerio Cioli at the center of the monument (Waźbiński 1987, I, pp. 155, 158, 164). The representation of the Arts in the guise of Graces, linked by a peaceful accord, would have quieted any academic dispute, symbolizing the harmony of the arts of Michelangelo shared equally among the three disciplines. With such finality garlands of evergreen leaves also were engraved—an image arbitrarily chosen by Vasari as a device for Michelangelo (Waźbiński 1987, I, pp. 172, 176). It was later adopted, in 1594, as the official emblem of the Academy of Design in recognition of the bond that existed between the institution and the monument to the Master (Cecchi 1993, p. 82). This trophy subsequently became an encomiastic prototype for artists like Federico Zuccari (see his fresco of the *Allegory of Father Design with his Daughters* in the palace of Trinità dei Monti) and also the emblem chosen by Gori to appear in the frontispiece to his own volume, where it is enriched by the fourth crown of Poetry.

[B. M.]

Bibliography: Anton Francesco Gori, in Ascanio Condivi, *Vita di Michelagnolo Buonarroti*, second edition, corrected and enlarged, in Florence, Gaetano Albizzini, 1746, pp. XXIII, XXVII-XXVIII; Giovanni Gori Gandellini, *Notizie istoriche degl'intagliatori*, Siena, Vincenzo Pazzini Carli & Sons, 1771; *Die Portraitdarstellungen des Michelangelo*, edited by Ernst Steinmann, Leipzig 1913; Julius Schlosser Magnino [Julius von Schlosser], *La letteratura artistica. Manuale delle fonti della storia dell'arte moderna* (Vienna 1924), translated by Filippo Rossi, second Italian edition, revised and updated by Otto Kurz, Florence 1956 (original edition, Vienna 1924 [but already in Id., *Materialien zur Quellenkunde der Kunstgeschichte*, Wien 1914-1920]; first Italian edition, corrected and enlarged by the author, Florence 1935); John Pope-Hennessy, *Two Models for the Tomb of Michelangelo*, in *Studien zur Toskanischen Kunst. Festschrift für Ludwig Heinrich Heydenreich zum März 1963*, edited by Wolfgang Lotz and Lise Lotte Möller, Munich 1964, pp. 237-43; Giorgio Settimo, *Ascanio Condivi, biografo di Michelangelo*, [Ascoli Piceno] 1975; Zygmunt Waźbiński, *L'Accademia Medicea del Disegno a Florence nel Cinquecento. Idea e istituzione*, 2 vols., Florence 1987; Alessandro Cecchi, "L'estremo omaggio al 'padre e maestro di tutte le arti.' Il monumento funebre di Michelangelo," in *Il Pantheon di Santa Croce a Florence*, edited by Luciano Berti, Florence 1993, pp. 57-82; Alessandra Giannotti, "'Fisso nel punto, che m'avea vinto.' Girolamo Ticciati, scultore 'sicuro' nella Firenze del Settecento," in *Atti e memorie dell'Accademia Toscana di Scienze e Lettere "La Colombaria,"* n.s., XLVI [LX], 1995, pp. 103-122; Stefano Corsi, in *Vita di Michelangelo*, catalog of the exhibition, Florence, Casa Buonarroti, 2001-2002, edited by Lucilla Bardeschi Ciulich e Pina Ragionieri, Florence 2001, p. 145, n. 108.

9. FRANCESCO BARTOLOZZI (FLORENCE *1727*-LISBON *1815*)
Portrait of Michelangelo, c*1802*

engraving, *330* x *245* mm.

In Richard Duppa, *The Life and Literary Works of Michel Angelo Buonarroti*,

London, John Murray et al., *1806*

Casa Buonarroti, Biblioteca, B. *293*

In his foreword to the *Life of Michelangelo*, in which this engraving is reproduced, Richard Duppa emphasizes that he made use of the two main bibliographical sources, namely the *Life of Michelangelo Buonarroti* by Ascanio Condivi and the *Lives* of Giorgio Vasari. Concerning the latter, Duppa explicitly states that he used the edition that was edited with commentary by Giovanni Bottari and printed in Rome by Pagliarini in 1759-60 (Duppa 1806, p. ix). This is an interesting detail, because during his Roman sojourn the young Bartolozzi collaborated precisely in this first "modern" edition of Vasari's treatise, which was illustrated with "portraits not engraved in wood, but rather in copper" (Jatta 1995, pp. 80-83, n. 11). In the preface to the first volume, Bottari justified his decision not to publish the names of the engravers because they were portraits that faithfully reproduced those in the original edition of the *Lives*, which were traditionally held to be by the hand of Vasari, or at least engraved under his supervision, with respect to which the eighteenth-century effigies were only enlarged and separated from the text so that their features might be better appreciated. In effect, comparing them with Vasari's originals, the modern engravings are philologically related, even in the decision to preserve the same style of dress for the personalities portrayed and, with rare exception, the same architectonic frames within which they were inscribed. Nevertheless, in a later preface that Giovanni Bottari added to the beginning of the third volume of his work, one reads: "The portraits and the other copperplate prints scattered throughout this work were engraved by the most diligent and esteemed Antonio Cappellani of Venice under the supervision of Giovanni Domenico Campiglia, a famous professor, and a few were engraved by the Florentine Francesco Bartolozzi who lived in Venice and was known for some beautiful maps that he engraved (*Proemio dell'Editore*, in Vasari 1568, ed. 1759-1760, III, p. x). Inasmuch as the paternity of the individual portaits is not identified, beneath the one of Michelangelo we clearly read the signature of the Venetian Antonio Capellan, which thereby excludes the name of Bartolozzi. Besides this, comparing the effigy engraved by Bartolozzi, displayed here, with the one by Capellan, one can grasp how the two artists had reproduced in rather different ways the characteristics of the Tuscan genius. In Capellan's interpretation, Michelangelo is portrayed in three-quarter profile, following the typology of the effigy by Jacopino del Conte, a prototype that had already been engraved by Giorgio Mantovano (cfr. Gori Gandellini 1771, I, p. 222).

On the contrary, in the effigy that was reproduced for Duppa's volume, the Florentine engraver opts for a more courtly presentation, with the face of Michelangelo shown in profile, according to the prototype signed by Giulio Bonasone, which dates to 1546. In this older engraving, the profile of Michelangelo is inscribed within a circular frame that includes, besides the name of the engraver, IVLIO B.F., the inscription MICHAEL ANGELVS BONAROTVS PATRITIVS | FLORENTINVS AN(nos) AGENS LXXII || QVANTVM IN NATVRA ARS NATVRAQVE POSSIT IN ARTE | HIC QVI NATVRÆ PAR FVIT ARTE DOCET | MDXLVI. It was used in the first edition of the *Life of Michelagnolo* by Condivi, which was published for the

first time in Rome by Blado in 1553 and reprinted in Florence in 1746. Bonasone's engraving was added to the frontispiece of this reprint, in a version that was slightly retouched with respect to the original yet recognizable by the decorative motifs on Michelangelo's vest (concerning this edition and the other derivations from Bonasone's engraving, see Massari 1983, I, p. 73-74, n. 85-87; cf. also *MDCCCLXXV. Per il centenario* 1875.) According to Richard Duppa, Bartolozzi derived the effigy of Michelangelo precisely from this last example. This is attested—beyond the similarity in the traits, most notably the prominent nose, the jutting forehead and the deep wrinkles on the face—by the common motif of the damask vest, which confers upon the artist a dignity appropriate to his advanced age. Bartolozzi engraved it shortly before leaving England, thus around 1802, when he had already achieved an absolute mastery of his art. By comparing it to works of that period, one can reasonably suppose that the Florentine engraver used etching as a base, together with the burin. This was a traditional technique that he habitually adopted especially when he had to undertake a reproduction, executed *d'après,* which is to say "after," an older image (Jatta 1995, p. 29.) Thus with respect to Giulio Bonasone's prototype, in which the head of Buonarroti dominates a neutral surface, in the version engraved by Bartolozzi the chiaroscuro of the background is rendered with virtuosity, in a way that makes the profile of the portrait stand out—a solution that the Florentine engraver had otherwise already adopted in previous portraits that were attributed to him in the already mentioned Pagliarini edition of the *Lives* of Vasari (cf. Jatta 1995, pp. 82-83, n. 11.)

[E.M.]

Bibliography: Giorgio Vasari, *Vite de' più eccellenti pittori, scultori e architetti,* [edited by Giovanni Gaetano Bottari], 3 vols., in Rome, Niccolò and Marco Pagliarini, 1759-60. Giovanni Gori Gandellini, *Notizie istoriche degl'intagliatori,* Siena, Vincenzo Pazzini Carli and Sons, 1771; Richard Duppa, *The Life and Literary Works of Michel Angelo Buonarroti,* London 1806; *MDCCCLXXV. Per il IIII centenario della nascita di Michelangelo Buonarroti,* photographic reproductions of the portrait of Michelangelo engraved by Giulio Buonasone in MDXLV and of the letter to Gio. Batta. della Palla, Florence 1875; Luigi Passerini, *La bibliografia di Michelangelo Buonarroti e gli incisori delle sue opere,* Florence 1875, p. 312; Stefania Massari, *Giulio Bonasone,* catalog of the exhibition (Rome, Calcografia Nazionale, 1983), 2 vols., Rome 1983; *Francesco Bartolozzi, incisore delle Grazie,* catalog of the exhibition (Rome, Villa Farnesina, 1995), edited by Barbara Jatta, Rome 1995.

MICHAEL ANGELUS BONARROTUS

NAT. M. CCCC. LXXIV. OB. M. D. LXIII.

THE LIFE

AND

LITERARY WORKS

OF

MICHEL ANGELO BUONARROTI.

By R. Duppa.

ΜΩΜΗΣΕΤΑΙ ΤΙΣ ΜΑΛΛΟΝ Η ΜΙΜΗΣΕΤΑΙ.
ΖΕΥΞΙΣ.

LONDON

PRINTED FOR JOHN MURRAY, FLEET-STREET; R. H. EVANS, PALL-MALL;
W. MILLER, ALBEMARLE-STREET; ARCHIBALD CONSTABLE AND CO.
EDINBURGH; AND JOHN ARCHER, DUBLIN;

BY T. BENSLEY, BOLT COURT.

M.DCCC.VI.

10. LE RIME DI MICHELANGELO BUONARROTI PITTORE, SCULTORE E ARCHITETTO CAVATE DAGLI AUTOGRAFI E PUBBLICATE DA CESARE GUASTI, ACCADEMICO DELLA CRUSCA

(The Poetry of Michelangelo painter, sculptor and architect transcribed from the original documents and published by Cesare Guasti, Accademico della Crusca)

Florence *1863*

Casa Buonarroti, Biblioteca, B.*471*

11. DIE DICHTUNGEN DES MICHELAGNIOLO BUONARROTI
(The Poems of Michelangelo Buonarroti)
edited by Carl Frey, Berlin 1897
Casa Buonarroti, Biblioteca, B. 490

(open to the page with a photo reproduction of the Portrait of Michelangelo by Francisco de Hollanda)

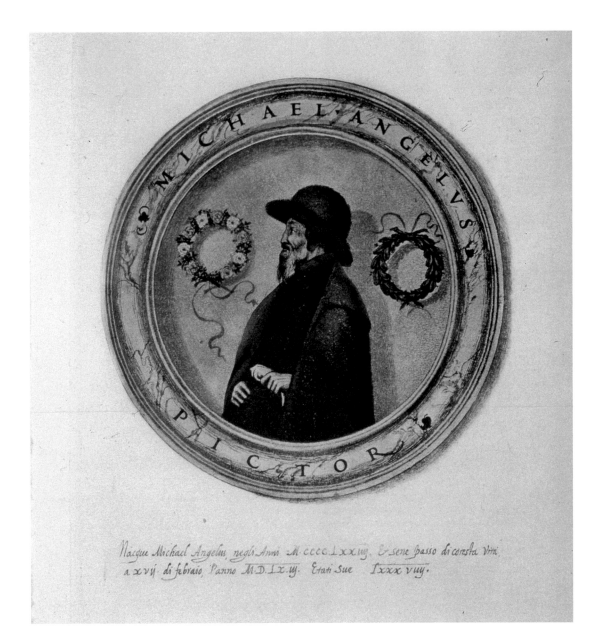

The first edition of the poems of Michelangelo was, as we read in catalog entry 7, the one desired by his grandnephew Michelangelo Buonarroti the Younger. While laboring with the best intentions, he had a profoundly altered redaction printed, with misleading corrections that reflected the moralistic concerns of the time. It nevertheless served as the text for about a century and a half.

In fact, one would have to wait until 1863 for the publication in Florence of an edition by Cesare Guasti, which was taken directly from the manuscripts in the Biblioteca Apostolica Vaticana and the Buonarroti Archives. The handsome nineteenth-century volume begins with a "discourse" entitled "Di Michelangelo poeta e di questa edizione delle sue rime" ("On Michelangelo the poet and this edition of his poems"). It expounds with pride the innovation of his undertaking but at the same time admonishes the reader "not to regard the poems as a philological entertainment." The author then furnishes a detailed description of the codices he consulted and, before going on to the poems, republishes the lecture that Benedetto Varchi held on the second Sunday of Lent in 1546 at the Florentine Academy on the sonnet "Non ha l'ottimo artista alcun concetto" ("The greatest artist has no concept") and the two lectures given by Mario Guiducci in 1626, that is, right after the first published edition of the poems appeared.

Carl Frey referred to the pioneering work by Guasti and perfected it to a certain extent. The German art historian, who emerges with a personal physiognomy in the bibliography of Michelangelo, published his work in 1897. Conducted with scientific rigor, it is still today an indispensable work on account of its rich apparatus and commentaries in which, among other things, Guasti attempted for the first time to establish a chronology of Michelangelo's poetry.

The book by Carl Frey is open to pages 278-79 to show an image of Michelangelo: the one painted in watercolor, probably in 1538, by Francisco de Hollanda (the sheet is preserved in the Library of the Escorial, see also the Introduction to this section).

Bibliography: Lirici del Cinquecento (1957), edited by Luigi Baldacci, Milan 1975, pp. 277-79; Michelangiolo Buonarroti, *Rime*, edited and with an introduction by Enzo Noè Girardi, Bari 1967, pp. VII-XXVII; *Michelangelo. Rime e lettere* edited by Paola Mastrocola, Turin 1992, pp. 9-43.

12. ERNST STEINMANN (JÖRDENSTORF *1866* - BASEL *1934*)
Die Portraitdarstellungen des Michelangelo
(The Portrait Representations of Michelangelo)
Leipzig *1913*
Casa Buonarroti, Biblioteca, B. *1479*.G.F.

(open to pages 94-95, with the reproduction of the portrait print of Michelangelo by Francesco Bartolozzi)

When Ernst Steinmann was very young, he applied himself to the study of theology and archeology, which he soon abandoned in order to dedicate himself to the history of art, concentrating his interests on the Italian renaissance and the figure of Michelangelo. As is known, he devoted all of his scholarly activity to the artist. It was Steinmann who suggested to Henrietta Hertz that she establish an art-historical library in the Palazzo Zuccari in Rome, which she purchased in 1904 to keep her own collections of art and which she opened to the public in 1908 as the Museum Hertzianum. Before long, the idea of creating a library was replaced by the more ambitious aim of creating a research institute, which opened in 1913. Following the death of Henrietta Hertz (1914) and the outbreak of the First World War, the institute was sequestered by the Italian government in 1915. It was only reopened in April 1920, under the guidance of Ernst Steinmann, who was its first director. A rich collection of his papers is preserved in the Biblioteca Apostolica Vaticana. Among his greatest works are the two volumes on the Sistine Chapel (*Die Sixtinische Kapelle*, Munich 1901-05) and the fundamental bibliography on Michelangelo which was produced in collaboration with Rudolf Wittkower (*Michelangelo Bibliographie 1510-1926*, Leipzig 1927.) The volume displayed here, *Die Portraitdarstellungen des Michelangelo,* appeared between these two works chronologically. Published as the third volume of "Römische Forschungen der Bibliotheca Hertziana," it represents a classic on the iconography of Michelangelo—a unique work in its genre together with the one by Paul Garnault, *Les Portraits de Michel-Ange*, Paris 1913. Of the two volumes the Casa Buonarroti owns respectively the final manuscript version that Steinmann presented to his publisher and the preparatory material for Garnault's volume (Archivio Buonarroti Moderno, Studi Garnault I, II, III.)

Steinmann's work is open to the page that contains the print of an engraving executed by Francesco Bartolozzi depicting Michelangelo. The caption for the image (*Idealporträt des jungen Michelangelo, gestochen in Jahre 1764 von F. Bartolozzi in London*) records the date and the place of the engraving. Following is a rapid but necessary biiographical excurses on the Florentine engraver: after an initial formation in his native city, the man who would become one of the most active and renowned engravers of reproductions in his time went to Venice, which at the time was the largest European center for the production and distribution of engraved prints. He then went to Rome and finally and definitively left Italy for London in 1764, bowing to the insistent pressures of Richard Dalton, the librarian and counselor to King George III. Becoming immediately famous and sought after especially by artists who competed for the reproduction of their works, Francesco Bartolozzi dominated the entire English world with his "puntinato" (pointed) style or engraving "a granito" (stippling). His engraved portraits, in which the strength of his line and the depth of his interpretation are most evident, quickly became highly valued.

The portrait of Michelangelo, displayed here, in which one can already appreciate the "puntinato" technique, was completed during the first part of his sojourn in London and probably derives from that fortunate portrait of the artist executed by Jacopino del Conte around 1535. In contrast to the painting, Bartolozzi's engraving is printed in reverse and instead of portraying an old Michelangelo, represents an "ideal" portrait of a young Michelangelo.

[E.L.]

Bibliography: Arte e storia in biblioteca, catalog of the exhibition, edited by Stefano Corsi and Elena Lombardi, Milan 1995, p. 67; *Francesco Bartolozzi. Incisore delle Grazie*, catalog of the exhibition, edited by Barbara Jatta, Rome 1995; Silvia Bianchi, "Francesco Bartolozzi e l'editoria veneziana del Settecento," in *Grafica d'arte*, XI, 2000, pp. 8-13.

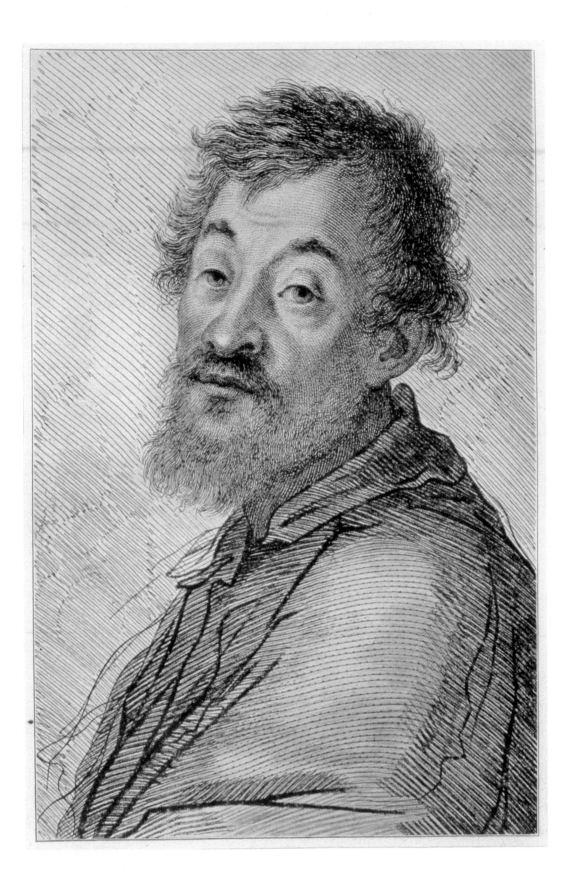

13. | THE SONNETS BY MICHAEL ANGELO BUONARROTI
now for the first time translated into rhymed English by
John Addington Symonds (Bristol *1840*-Rome *1893*)
Venice *1906 (?)*

Casa Buonarroti, Biblioteca, B. *163*

(open to pages 48-49: on page 48, Michelangelo portrays Vittoria Colonna)

Al cor di zolfo, a la carne di stoppa	*A heart of flaming sulphur, flesh of tow,*
a l'ossa che di secco legno sièno;	*Bones of dry wood, a soul without a guide*
a l'alma senza guida e senza freno	*To curb the fiery will, the ruffling pride*
al desir pronto, a la vaghezza troppa,	*Of fierce desires that from the passions flow;*
a la cieca ragion debile e zoppa	*A sightless mind that weak and lame doth go*
al vischio, a' lacci di che 'l mondo è pieno,	*Mid snares and pitfalls scattered far and wide;*
non è gran maraviglia, in un baleno	*What wonder if the first chance brand applied*
arder nel primo foco che s'intoppa.	*To fuel massed like this should make it glow?*
A la bell'arte che, se dal ciel seco	*Add beauteous art, which, brought with us from heaven,*
Ciascun la porta, vince la natura,	*Will conquer nature — so divine a power*
quantunche sé ben prema in ogni loco;	*Belongs to him who strives with every nerve.*
s'i' nacqui a quella né sordo né cieco,	*If I was made for art, from childhood given*
proporzionato a chi 'l cor m'arde e fura,	*A prey for burning beauty to devour,*
colpa è di chi m'ha destinato al foco.	*I blame the mistress I was born to serve.*

John Addington Symonds was undoubtedly a leading figure among the great European intellectuals of the nineteenth century. Two characteristics of his childhood—his love for poetry and art and his rather fragile health—would mark the entire course of his brief life.

He was a sensitive and original poet, and also a notable literary critic. His most important scholarly work, to which he dedicated ten long years (1875-1886), was his seven-volume *Renaissance in Italy*. More than a systematic history, it consists of a series of broad studies that reveal sensibility, broad culture and unconditional love for Italy. He also worked on English literature, Greek poetry and studied not a few great personalities, from Shelley to Whitman, from Cellini to Campanella and Michelangelo, whose sonnets Symonds was the first to translate into English (1878). A few months before his death in 1893, he succeeded in publishing a large and well-respected two-volume biography of the artist, which, as one reads on the title page, had been written after a careful examination of the papers in the Buonarroti Archives. Symonds was able to see the original Michelangelo documents in October 1891—a feat, as his biographer Phyllis Grosskurth recounts, that took an arduous effort to achieve. From this came his conflicts with Carl Frey, who had shared the identical aim. "He hates me, and tries to keep all mss. to himself," our poet said of him, who did live not long enough to see the completion of Frey's research. The German art historian, who appears with a personal physiognomy in the bibliography of Michelangelo, published his work, *Die Dichtungen des Michelagniolo Buonarroti*, some years later in 1897. Conducted with scientific rigor it

is still today an indispensable work on account of its rich apparatus and commentaries, in which, among other things, he attempted for the first time to establish a chronology of Michelangelo's poetry.

John Addington Symonds died in 1893; a long-lasting moralistic oblivion fell upon his autobiography. It was not published until ninety years after his death, in 1984, and was translated into Italian the following year.

In 1877, the poet was forced to leave England, and it proved to be a final farewell. In that year, he was removed from his chair of poetry in Magdalen College in Oxford following an accusation of immoral behavior that was later withdrawn. He nevertheless was a personality who, not unlike Oscar Wilde, was too removed from the conventionality of the Victorian era to be accepted by his compatriots. At the same time, symptoms of tuberculosis had manifested themselves, recommending to him more mild climates. He found refuge in Italy, but also went on long medical retreats in Davos, the famous Swiss locality that was a destination—not only in Symonds's time—for those who suffered from delicate illnesses, and which became for him almost a second homeland. Robert Louis Stevenson, the great Scotch writer who also suffered from fragile health, made his acquaintance in Davos in 1880. He became his friend and called him "the best of talkers, singing the praises of the earth and the arts, flowers and jewels, wine and music, in a moonlight, serenading manner, as to the light guitar." In 1884, Symonds dedicated to him his book *Wine, Women, and Song. Mediaeval Latin Students' Songs*, which contained his translations from Latin of goliardic songs from the Middle Ages.

The rare little book that we display, given to the Casa Buonarroti by Leonard Borgese in 1971 and altogether ignored by scholars, contains his translation of the sonnets of Michelangelo. It was published by Rosen in Venice, but printed in Prato, in Tuscany. Definitely posthumous, we refer to it here as having been published in 1906 because that is the date that one finds on the illustrations, which are signed GMS 1906, a mark that we are not able to identify. This object of delicate handiwork bears many small images, reflecting a taste that stands between symbolism and art nouveau, commenting always in even pages upon sonnets that appear on the opposite pages to the right. We are most likely dealing with miniaturized reproductions of engravings or drawings of larger format, as one can also deduce from the fact that in order to decipher the writing just cited one must use a magnifying lens.

So far as Michelangelo is concerned, the text of 1878 (which nevertheless also includes the translation of a few poems by Tommaso Campanella) is reproduced faithfully in this volume that is as lovely as it is mysterious. In addition, it reproduces the well-informed and flowing introduction in which Symonds compliments himself for being able, among other things, to employ the critical edition of "Signor Guasti" (as he calls him in Italian)—that is, the edition which in 1863 had finally made sense of Michelangelo's rhymes for the first time following the distorting commentaries that had been written about them two and half centuries earlier by Michelangelo Buonarroti the Younger (catalog #7).

The page opening that we have chosen does not lose its charm if we call attention to a detail that certainly would not have pleased the translator: the illustration that shows an imaginary moment in the relationship between Vittoria Colonna and Michelangelo that corresponds to a sonnet dedicated

not to the marquise of Pescara but to a great friend of the Master, the young and handsome Roman patrician Tommaso de' Cavalieri.

At the beginning of this entry, we have transcribed the sonnet in its original construction, placing beside it Symonds's translation in order to emphasize the difference between the bitter poetry of Michelangelo and the delicate versification by the English writer, along with his remarkable freedom of reading and interpretation.

Bibliography: Le Rime di Michelangelo Buonarroti, pittore, scultore e architetto, edited by Cesare Guasti, Florence, 1863; John Symonds, *The Life of Michelangelo Buonarroti: Based on Studies in the Archives of the Buonarroti Family,* 2 vols., London, 1893; Phyllis Grosskurth, *John Addington Symonds. A Biography,* London, 1964; Phyllis Grosskurth, *The Woeful Victorian: A Biography of John Addington Symonds,* New York, 1964; *The Memoirs of John Addington Symonds,* edited by Phyllis Grosskurth, London and New York, 1984

14. | BENJAMIN BRITTEN (LOWESTOFT *1913*-ALDEBURGH *1976*)
Seven Sonnets of Michelangelo

op. 22, Set to Music for Tenor Voice and Piano

London 1943

Since the second half of the nineteenth century, no Italian poet has moved or inspired the imagination of composers more than Michelangelo. Dante and Leopardi, for example, proved too arduous to be translated into music. Petrarch, who attracted the Renaissance genius of Dufay, Marenzio and Lasso, was willingly adapted by Liszt, Pizzetti and even Schoenberg, yet only as a *topos*—an occasion—not for the intimate affinity between poet and composer. Michelangelo, on the other hand, inspired three seminal cycles for voice and piano: Hugo Wolf (1897), Dmitri Shostakovich (1974)—in both cases their last *Lieder*—and the Seven Sonnets of Michelangelo (1940) by Benjamin Britten, the greatest English composer of the twentieth century.

In 1939, many British cultural personalities were openly critical of English social and war politics. Thus it was that the composer Tippet was imprisoned as a conscientious objector. Accompanied by the tenor Peter Pears, Britten decided to follow Auden's example by emigrating to America as a sign of protest. In those months, Britten's declared pacifist stance inspired ever more negative criticism of his music, and his departure, which took place in May of that year, was greeted by public epithets such as "deserter, coward." Britten, who was so disgusted that he thought seriously about the possibility of acquiring American citizenship, took up residence in Amityville, New York. Far from English surroundings, he tried for the first time to set poetry in a foreign language to music. In October 1939, a month after the outbreak of the war, he completed the cycle of the *Illuminations* of Rimbaud, written for voice and strings. Its success was immediate and great. Despite the recent hostilities, it was performed in London in January 1940.

Encouraged by its success, Britten then attempted the Italian of Michelangelo. The choice was courageous: the cycles by Wolf and Shostakovich are respectively in German and Russian, with translations that are not particularly good. In English, on the other hand, the selection could have profited from the splendid versions by Wordsworth, Longfellow, Santayana and above all Emerson. Perhaps, along with physical exile, Britten opted for a sort of cultural exile, since his selection of a decidedly European musical style, structured upon characteristics that the English would call "continental," respects and corresponds to the original language.

What attracted Britten to Michelangelo was his indivisible joining of civic and erotic experience. In the same way, the life of the musician was shared between politics and love for Peter Pears, his companion after 1936. It was his first work conceived entirely for Pears. We have evidence of their performance in the recording made in 1954, which is exemplary from a musical perspective, though marked by the heavy English accent of the tenor.

In March 1942 Britten and Pears decided to return to their homeland. Upon his arrival in Liverpool, the twenty-nine year old composer was prosecuted for conscientious objection. Wisely, the jury declared him incompetent and acquitted him. The Michelangelo cycle, completed in October

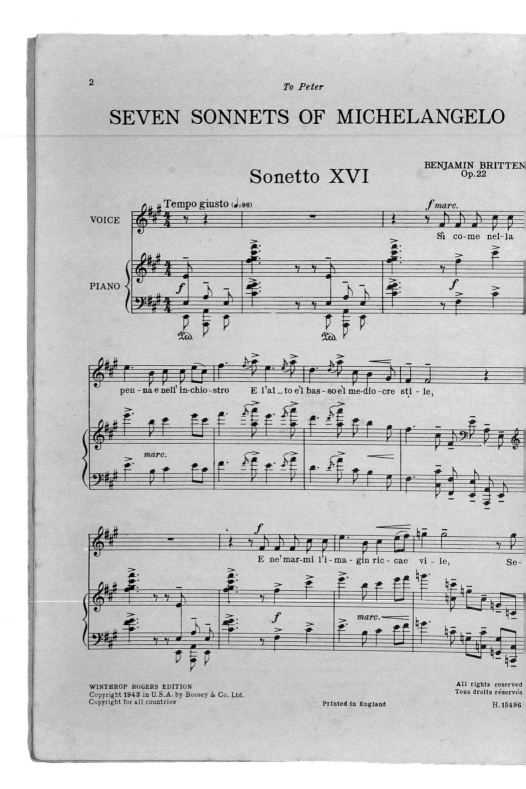

1940, was finally performed for the first time in September 1942 at Wigmore Hall in London and published in 1943 by Winthrop Rogers Edition, publisher for the Boosey & Hawkes group.

A famous drawing by Michelangelo was chosen for the cover, a nude from behind whose features decidedly recall Britten's. What is more, the raised arms of the nude call to mind the pose of an orchestra director—a game of allusions that was probably desired by the composer, who was also a great pianist and director.

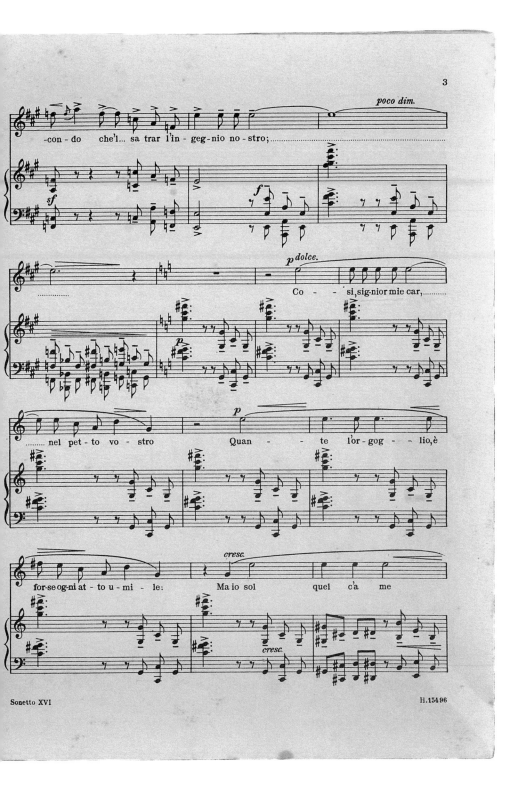

Sonetto XVI

The copy from the first edition displayed here bears an ownership signature with the year 1944.

[G.N.]

Bibliography: Donald Mitchell and John Evans, *Benjamin Britten, 1913-76: Pictures from a Life*, London 1978; Eric Walter White, *Benjamin Britten: His Life and Operas*, London 1983; John Evans, Philip Reed, Paul Wilson, *A Britten Source Book*, Aldeburgh 1987; Donald Mitchell and Philip Reed, *Letters from a Life: Selected Letters and Diaries of Benjamin Britten*, Berkeley 1991; Humphrey Carpenter, *Benjamin Britten: A Biography*, London 1992.

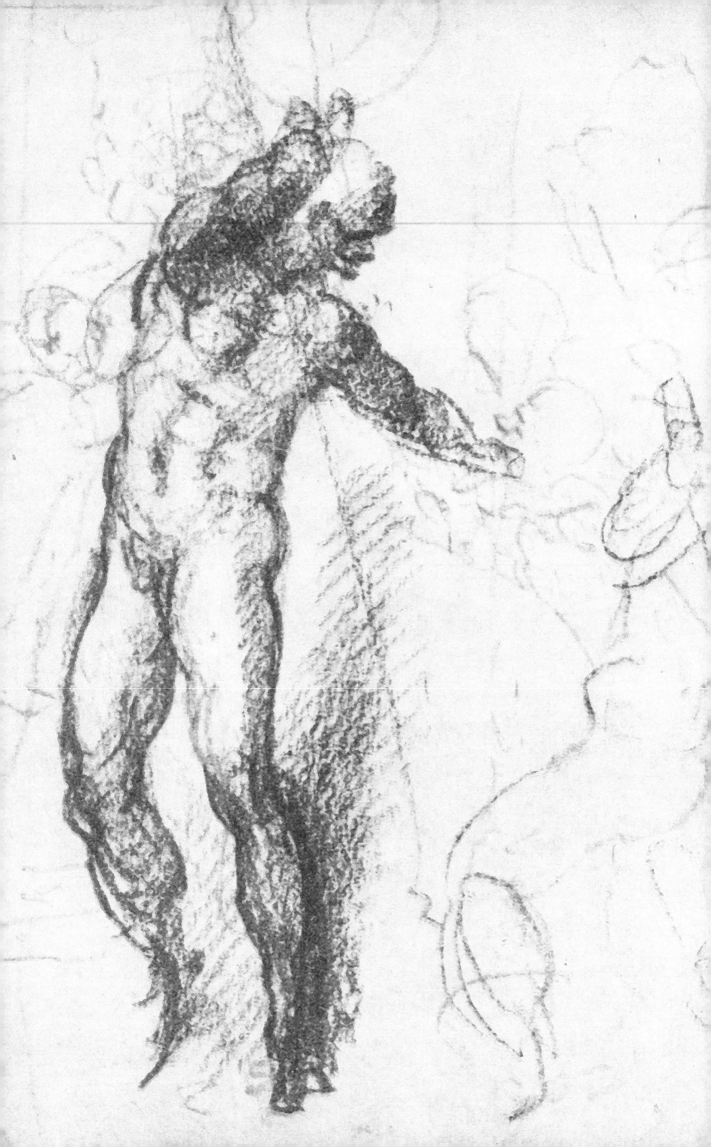

THE DRAWINGS OF
MICHELANGELO
AT CASA BUONARROTI

In many ways, it can be useful to cite the famous episode related by Vasari according to which "a short time before dying [Michelangelo] burned a large number of drawings, sketches and cartoons that he had drawn with his own hand so that no one might see the labors he endured and the ways he tempted his genius, so as not to appear anything but perfect." We know for certain that this great bonfire, lit twice, was the most conspicuous but presumably not the only one. Thus we are able to understand why the corpus of Buonarroti drawings often presents lacunae to scholars and is sometimes problematic even from the standpoint of attribution: precisely on account of the impossibility of tracing in a continuous line the history that accompanies the artistic events of a long life.

The drastic destructions notwithstanding, there remained in Rome at the death of Michelangelo some cartoons at his dwelling in Macel de' Corvi. His drawings were also already for sale on the market especially in Rome. There were many sheets left in Florence at the family's home and in his studio in Via Mozza, without counting the not small number of drawings he gave to friends. Concerning these gifts, it is worth emphasizing that the artist believed in the imperfection (that is, in the planning and preliminary character) of the graphic mark, and used and re-used sheets for various purposes. One example is the *Nude from Behind* at the Casa Buonarroti, a wonderful invention traced on a sheet which, refolded in fourths, would at a later time be re-used for noting minor expenses. Yet altogether, throughout the years, the artist took advantage of graphic means to make gifts for friends who were particularly dear to him. These are the drawings that today are called, by a fortunate definition, "presentation drawings." Works that are highly elaborated, classically finished and concerning complex subjects, they are almost always profane and often not easy to interpret. Among the recipients were Gherardo Perini, Tommaso Cavalieri and Vittoria Colonna. These drawings survived the destructive fury of the artist not only because they were jealously guarded by their owners but also precisely because they had been brought to completion and hence were "perfect."

Cosimo I de' Medici had had for some time the notion to collect the drawings of famous artists when Michelangelo was still alive, though a resident for many years in Rome and far from the events of the Florentine court. The duke, therefore, with the aim of pursuing his own collecting desires with respect to Michelangelo did not turn to him directly but instead to the aforementioned Tommaso Cavalieri, the young Roman patrician who had been a friend of Michelangelo since 1532 and who was the recipient of a group of presentation drawings of the most consistently extraordinary quality. Already in 1562, two years before the death of his great friend, Cavalieri found himself obliged to give to Cosimo I the splendid *Cleopatra* drawing which he had received as a gift from Michelangelo about thirty years earlier, but not without keeping himself from stating in the letter that accompanied the forced surrender that to be deprived of that work procured him no less suffering than losing a child. What is more, there is every evidence that Cosimo I awaited the death of the great old man for an easily foreseeable inheritance.

Michelangelo, detail, *Study for a Christ in Limbo*

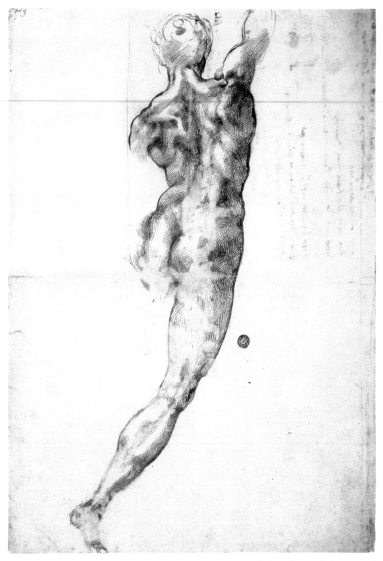

Michelangelo, *Nude from Behind*

It is therefore no wonder that Cosimo, in a letter sent to his ambassador Serristori less than a month after the death of Michelangelo, would label the artist's burning of drawings "an act not worthy of him." The Florentine court felt a great disappointment on account of a decision that had taken from the duke a patrimony that he already considered his own.

This is why Vasari warmly advised Leonardo Buonarroti, Michelangelo's nephew and heir, first of all to ask the duke's pardon for the "misdeed of his uncle," and, moreover, to offer him, as a consolation gift, that which still remained by the artist in his studio in Via Mozza in Florence. In a letter dated 4 March 1564, written the day before the ducal complaint to Serristori, Vasari pleaded:

> Neither would it seem to me inopportune, my dear Messer Lionardo, […] that your lordship should write a letter to his Excellency expressing regret for the loss that has befallen the city and his Excellency in this death, and that, as I have noted you have written, you grieve on account of [Michelangelo] not having left either drawings, or cartoons, or models, because you had planned to share them with him. But since he is gone and has left

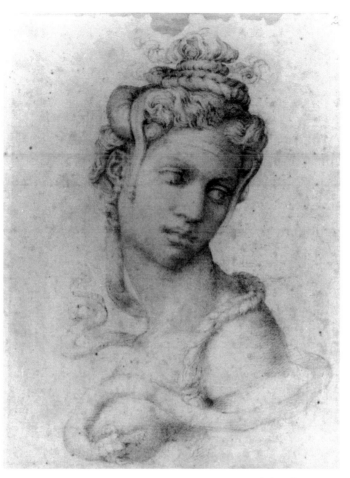

Michelangelo, *Cleopatra*

everything to you only, write to him that you will be the same as your uncle in faith and servitude and that, since here there is nothing but the things in via Mozza, that these will be, if it pleases him, his, asking that he does not fail to give you the same protection he had given to Michelangelo before he had passed into the next life.

Leonardo promptly obeyed, but went even further, giving to Cosimo the very beautiful marble tablet with the *Madonna of the Stairs*, executed by Michelangelo when he was barely an adolescent, which had always been the property of the family. He also recovered at a dear price on the Roman market the few, yet most precious, autograph sheets that were still available. Among these is the splendid sheet with the *Annunciation*, today in the Prints and Drawings Room at the Uffizi. Thus, by this means, as we learn once again from Vasari, many "drawings, sketches, and cartoons from Michelangelo's hand" passed into the Medici collection. A few months later, when Gherardo Perini died, "three sheets with some 'divine heads' in black pencil" became the property of Francesco de' Medici, "the prince of Florence, who keeps them as joys, as indeed they are." The "divine heads," now securely identified by critics, now are also a part of the voluminous catalog of the above-mentioned Print Room.

When, in the second decade of the seventeenth century, Michelangelo Buonarroti the Younger, Leonardo's son, decided to furnish a series of monumental rooms in the family home in Via Ghibellina, transforming part of his own living quarters into a museum dedicated to the memory

of his great ancestor and to the exultation of the splendor of the family, the *Madonna of the Stairs* and a portion of the drawings given to the Medici were returned to him, as a token of high esteem, by Grand Duke Cosimo II. The *Annunciation* was missing from the papers of Michelangelo that were returned to the home, yet there was one new and very valuable acquisition: that famous drawing depicting Cleopatra that Cavalieri had had to give up with much pain for the Medici collections.

Michelangelo the Younger no doubt was grateful for the arrival in Casa Buonarroti of an extraordinary work, especially notable for the biographical history that we have mentioned. It is no wonder that such a thoughtful grand nephew would carefully organize the largest portion of the drawings, gathered into volumes, in the cabinets of the so-called 'Study'. However he chose to display the returned *Cleopatra* in his 'Writing Cabinet,' into whose constrainted yet refined atmosphere he would withdraw to attend to his studies. Yet in those years, still other sheets by Michelangelo that seemed particularly beautiful to the master of the house were framed and hung on the walls of the new rooms. For example, in the 'Room of the Angels,' the dear cartoon of the *Madonna and Child*, which, without a doubt, is one of the most moving masterpieces in the collection. In the 'Night and Day Room,' the preliminary drawing for the façade of San Lorenzo deserves mention for the special regard (rare in those days) that Michelangelo the Younger attributed to an architectural drawing.

From this time on, the drawings of Michelangelo that remained in the Medici collection and those that were kept with great devotion by Michelangelo the Younger formed two nuclei independent of one another. The collection belonging to the Buonarroti family, which would soon be enriched with a few items belonging to Bernardo Buontalenti, was at the time the largest in the world. With its more than two hundred sheets, it remains so today, despite the serious assaults it suffered. In fact it was impoverished at the end of the eighteenth century, first by the sale that the revolutionary Filippo Buonarroti made to Jean-Baptiste Wicar, the French painter and collector who was regrettably famous also for the uninhibited acquisitions made in the name of France and its emperor, and by a second sale in October 1859 that the Cavalier Michelangelo Buonarroti made to the British Museum. For precise accounts of these transfers of property, refer to the 1998 essay by Dora Thornton and Jeremy Warren, which, with the aim of summarizing the acquisition of sheets of Michelangelo's sheets by the British Museum, ends up offering a very interesting, detailed and sympathetic narration of the last fifty years in which the Casa Buonarroti remained the property of the family. Not a few important sheets left the Casa Buonarroti collection through the above-mentioned sales, especially those with figures, in favor of works that now are part of the collections of the British Museum, the Ashmolean Museum, even the Louvre.

As the collecting predilections of Cosimo I teach us, already in the sixteenth century drawings, especially those by artists with widespread and established fame, were appreciated and sought after. Yet surely the extraordinary importance of this means of expression as a preparatory moment in the creation of paintings, sculptures and monuments was not yet understood. As we have seen, Michelangelo wanted to destroy that which did not seem to him well finished and complete. (We remark in passing and only in parentheses in the present context the fascinating difference between this type of incompletion and Michelangelo's "non finito.") As a consequence, we have to look to a time much closer to ours to see understood and appreciated the intrinsic value of graphic work in general and of architectural drawings in particular. As we have noted about the above-mentioned sales, figure studies took precedence. For this reason, too, the Casa Buonarroti possesses the largest

number of architectural drawings by Michelangelo in the world, approximately eighty.

No doubt deserving separate mention are the twenty-eight drawings of fortifications—a particularly prized portion of the collection—that were the fruit of the firm and passionate adherence of the Master to the ideals upon which the second Florentine Republic (1527-30) was founded. We will discuss these at greater length in the entry for item 22, which concerns a plan for a fortification, again to recall that this group of sheets bears witness to a unique period in Michelangelo's biography as a citizen and a personality with notable political significance.

In 1858, Cosimo Buonarroti died. The last direct heir, he possessed the most consistent collection of Michelangelo's papers. In his will, he left them for public enjoyment, together with the palace in Via Ghibellina and its contents. Since that time, even during difficult years for the institution, the drawings were permanently displayed in the museum in frames and showcases. Only in 1960 were they finally delivered from the "humiliating defeat" of a "careless custody" that had caused not a few damages to the sheets, as Paola Barocchi, who initiated this truly meritorious action, recounts. At the time, Giovanni Poggi, the well-respected Michelangelo scholar, was the director of the Casa Buonarroti, while Giulia Sinibaldi was the chief of the Prints and Drawings Room at the Uffizi. In the spring of 1960, the two scholars decided upon the emergency removal of all of the drawings in order to conserve them. At the same time, Barocchi was entrusted with assembling a complete catalog of the Casa Buonarroti collection, which was also to include the sketches of Michelangelo in the Buonarroti Archives (of which a few rare examples can be seen in this exhibit). Thanks to Sinibaldi's initiative, the study of Michelangelo's graphical works in the Uffizi was also added "in such a way as to reunite, for ease of consultation, all of the material from the Florentine collections." Still today, the three famous volumes bound in red, which were published between 1962 and 1964 as the result of monumental research and from which we have extracted the citations for this paragraph, constitute the essential and irreplaceable resource for whomever wishes to understand and deepen his knowledge of Michelangelo's works in the Florentine collections.

Thus removed to the Prints and Drawings Room at the Uffizi where they were conserved, the drawings of the collection returned to the Casa Buonarroti only in 1975. In 1960, facsimiles of the drawings of Michelangelo were put into the frames and displays cases in place of the originals to relieve in some measure a traumatic absence. After the large exhibition celebrating the fifth centenary of the birth of Michelangelo and together with the return of the drawings to Casa Buonarroti, the walls of the museum were again filled with facsimiles. By then old and above all no longer reflecting current museum standards, these copies were substituted in the middle of the 1980s with a temporary display of the originals. Because we now understand the exacting standards of conservation that prohibit the permanent display of graphic works, small groupings from the collection are presented in rotation in a room of the museum outfitted for that purpose.

From what has been said thus far, it is evident that the patrimony of the Casa Buonarroti also includes numerous family papers (dating from 1399 to 1815) and many autographs of Michelangelo (letters, poems, memoirs, but also drawings), which are now reunited in the 169 volumes of the Buonarroti archives. These archives, too, underwent a long exile. A nearly century-long sojourn at the Laurentian Medici library in Florence brought significant organization and conservation to the archives during years in which the resources of the Casa Buonarroti were at their limits.

For these actions, we must always remain grateful. Yet it is wonderful to note that, a few years ago, when the time seemed right, all of the papers were effectively returned to the Casa Buonarroti and placed in an ideal environment that had been prepared for them.

Just as in 1975, when director Charles de Tolnay witnessed the return of the drawings of Michelangelo and his school from the Prints and Drawings Room at the Uffizi following their fortuitous restoration—the drawings of Michelangelo and his school that constitute the collection at Casa Buonarroti—so today we can be thankful for the return of archives with which the research we have in progress requires a daily relationship, and to which it is necessary to turn in order to understand and clarify moments in the art and history of the family.

Bibliographic Notes: The Drawings of Michelangelo

The drawings that are now part of the collection of the Casa Buonarroti have been cited often in Michelangelo studies since the time of Vasari. The results of those centuries of research up through the 1960s are listed in the three-volume catalog of Paola Barrocchi (Florence, 1962-64), which has been mentioned several times in this essay. These foundational volumes include entries with exhaustive bibliography and photographic reproduction of the recto and verso, often accompanied by details, of each drawing in the collection.

The *Corpus dei disegni di Michelangelo* edited by Charles de Tolnay (Novara, 1975-80) brings the state of studies up through the end of 1960s, limited, however, to the autograph sheets of Michelangelo or those that have been attributed to him by the author. In 1985, a volume with reproductions of all of the drawings in the collection was published, accompanied by summary descriptions by Alessandro Cecchi and Antonio Natali. The volume opens with an illuminating introduction by Luciano Berti (*Michelangelo. I disegni di Casa Buonarroti*, Florence 1985). The studies of Michelangelo from the *Codice Coner*, preserved almost entirely at the Casa Buonarroti, were the subject of *Studi di Antichità dal Codici Coner* (Turin, 1987) edited by Giovanni Agosti and Vincenzo Farinella. Many drawings in the collection are discussed by Michael Hirst in his *Michelangelo and His Drawings* (Yale, 1988).

The drawings of the collection have constituted one of the main, and by now, classical columns of the two major exhibitions on the graphic works of Michelangelo curated by Henry A. Millon and Michael Hirst in 1988-89, which were held at the Casa Buonarroti, the National Gallery of Art in Washington, and the Louvre. The respective catalogs (*Michelangelo Architect* and *Michelangelo Draftsman*, Milan 1988-89) enriched the bibliography for the items that were included in the exhibition.

In the last decade, the sheets in the collection have been included in important expositions in Italy and abroad. In particular, a rich anthological selection animated the exhibition "The Genius of the Sculptor in Michelangelo's Work," which was held in 1992 under the direction of Pietro C. Marini at the Montreal Museum of Fine Arts. Also, a large grouping of architectural drawings was presented at the various venues (Venice, Washington, Paris, Berlin) of the exhibition "Rinascimento. La rappresentazione dell'architettura da Brunelleschi a Michelangelo," curated by Henry A. Millan and Vittorio Magnano Lampugnani (Milan, 1994-95).

We cannot neglect to mention in this bibliographical note the volume edited by Frank Zöllner, Christof Thoenes and Thomas Pöpper, *Michelangelo 1475 to 1664* (Cologne, 2007), which stupefied and puzzled specialists. The section dedicated to the drawings of the artist (pp. 492-751) denied without explanation the attribution, by now consecrated by critics, of many drawings of Michelangelo preserved in the most prestigious collections including, of course, the Casa Buonarroti.

An always homogenous group of drawings from the collection, varied each time for reasons of conservation, are at the heart of that particular form of promotion of knowledge about the Casa Buonarroti comprised in the exhibition, *Invito in Casa Buonarroti*, curated by Pina Ragionieri, which since 1994 has visited London, Edinburgh, Albi, Tokyo, Kyoto, São Paolo, Valencia, Atlanta, Toledo (Ohio), Rome and l'Aquila. Since 2000, this project has been flanked by *Michelangelo: grafia e biografia* curated by Lucilla Bardeschi Ciulich and Pina Ragionieri—a show, which like the preceding one, is composed exclusively of items belonging to the Casa Buonarroti, in which a copious sample of autograph sheets are placed alongside drawings connected to salient moments in the life of Michelangelo. Envisioned for an Italian speaking audience, the venues to which this exhibition has thus far traveled include Milan, Brescia, Rome, Biel/Bienne, Catania, San Benedetto del Tronto and Cosenza.

Around one of the masterpieces of the collection, the *Study for the Head of Leda* (a drawing that appears in this exhibition), an exhibition was organized in Turin and Bonn (28 June-28 October 2007) tracing, with the presence of four drawings of fortifications, the story of the relationships among the second Florentine Republic, Michelangelo and Alfonso d'Este (see the description of item 21 in this catalog).

The exhibitions that have been held annually in the four rooms on the ground floor of Casa Buonarroti have, for more than twenty years, provided frequent occasions for research and studies on portions of our graphic collection. In particular, one may refer to the catalogs of the following exhibitions: *Disegni di fortificazioni da Leonardo a Michelangelo*, curated by Pietro C. Marani (Florence, 1984); *Michelangelo e i maestri del Quattrocento*, curated by Carlo Sisi (Florence, 1985); *Michelangelo e l'arte classica*, curated by Giovanni Agosti and Vincenzo Farinella (Florence, 1987); *Le due Cleopatre e le "teste divine" di Michelangelo*, curated by Paola Barocchi (Florence, 1989); *Costanza ed evoluzione nella scrittura di Michelangelo*, curated by Lucilla Bardeschi Ciulich (Florence, 1989); *Rodin e Michelangelo*, curated by Maria Mimita Lamberti and Christopher Riopelle (Milan, 1996-97); *L'Adolescente dell'Ermitage e la Sagrestia Nuova di Michelangelo*, curated by Sergej Androsov and Umberto Baldini (Siena, 2000); *Vita di Michelangelo*, curated by Lucilla Bardeschi Ciulich and Pina Ragionieri (Florence, 2001); *Il mito di Ganimede prima e dopo Michelangelo*, curated by Marcella Marongiu (Florence, 2002); *Daniele da Volterra amico di Michelangelo*, curated by Vittoria Romani (Florence, 2003); *Vittoria Colonna e Michelangelo*, curated by Pina Ragionieri (Florence, 2005); *Michelangelo e il disegno di architettura*, curated by Caroline Elam (Venice, 2006); *Michelangelo architetto a San Lorenzo. Quattro problemi aperti*, curated by Pietro Ruschi (Florence, 2007).

15. | MICHELANGELO
Crested Head, 1503-1504
ink, *75* x *56* mm.
Inv. *59* F

The subject of this sketch by Michelangelo is summarized by Tolnay as follows: "Head of a warrior seen in profile with a fabulous head-covering composed of fur from which bat wings emerge." It is to be noted that the effect of fur is obtained with a rather simple trick, tracing several curved lines on the white of the paper. The motif of bat wings on an imaginative helmet is characteristic of the end of the fifteenth century in Florence. In fact, the small sheet has been considered a youthful work in the literature.

Thode relates this study to the work for the famous Michelangelo cartoon (1504) that he prepared for the fresco dedicated to the *Battle of Cascina*, which, as we know, was never executed, but was to have been located in the Sala del Maggior Consiglio, today the Salone dei Cinquecento, in the Palazzo Vecchio in Florence. On the other hand, precisely between 1503 and 1504, work began on the *Battle of Anghiari*, which Leonardo would begin to paint in competition on the opposite wall of the same room. In a contemporary copy, the Leonardo fragment appears populated with imaginative helmets decorated with zoomorphic elements. At least two helmets of this type must have been present in the cartoon of Michelangelo, since we find them in the partial copy of the *Battle of Cascina* executed by Aristotele da Sangallo, now at Holkham Hall. There is thus no lack of support for the seductive hypothesis advanced by Thode; nevertheless, the most attentive critics (from Barocchi to Tolnay) have not accepted it.

It is certain that this drawing is inspired by the examples of Verrocchio and Leonardo, and it constitutes Michelangelo's point of departure for a chronologically homogenous series of imaginative helmets of which even more refined and complex examples survive. For comparison, one can profitably refer to the *Two 'Divine Heads' of Warriors with Helmets* in Rotterdam, the *Sketches of Heads with Helmets* at the Louvre, and the *Study of a 'Divine Head' with Imaginative Helmet* in Hamburg. The allusion in these titles to "divine heads" points to a well-known designation ("divine heads in black pencil") coined by Vasari for three graphic masterpieces given by Michelangelo to the young Florentine Gherardo Perini at the beginning of the 1520s.

To return to the theme of the present sheet on display, it is enough to recall the beautiful helmet of Zenobia among the "divine heads" (Uffizi, G.D.S.U., inv. 598 E). Nevertheless, the subject, reduced to a purely decorative element, will return in later examples—not only in graphic form—from the helmet of Lorenzo Duke of Urbino in the New Sacristy to the *Head of a Woman* (inv. 1895-9-15-493) in the British Museum, to the lost drawing known as *The Count of Canossa*, known through a copy, which is also at the British Museum (inv. 1895-9-15-492).

Bibliography: Henry Thode, *Michelangelo. Kritische Untersuchungen über seine Werke*, 3 vols., Berlin 1908-1913, II, p. 340, III, p. 24, n. 52 a; Paola Barocchi, *Michelangelo e la sua scuola. I disegni di Casa Buonarroti e degli Uffizi*, 3 vols., Florence 1962-1964, I, p. 6, n. 2; Charles de Tolnay, *Corpus dei disegni di Michelangelo*, 4 vols., Novara 1975-80, I, p. 48, n. 32; *Le due Cleopatre e le "teste divine" di Michelangelo*, catalog of the exhibition in Casa Buonarroti, Florence 1989, *passim*.

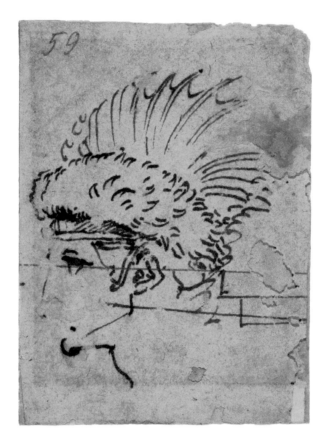

16. | MICHELANGELO
Studies for a Cornice and for the Nudes for the Sistine Ceiling, 1508-150
black pencil, ink, *414* x *271* mm.
Inv. *75* F

Michelangelo probably undertook the immense project of the decoration of the ceiling of the Sistine Chapel at the beginning of the autumn of 1508. The images drawn on this interesting and lively sheet more or less date to this time. It is likely that the study for a cornice was executed first, decorated with shell and acorn motifs, the latter being present in the emblem of the Della Rovere family, from which came the pope who commissioned the work, Julius II. This motif was not used for the large ceiling cornice, which lacked decorative elements, being inspired by classical models and more monumental in effect. Instead, the motif is found in the frames that outline the spandrels and lunettes, where the moldings nevertheless appear simpler.

From the beginning Michelangelo planned to include figures in the decoration of the ceiling, the so called *Ignudi* (nude males), among which we can recognize on this sheet the sketches for the Ignudo to the left of the Cumaean Sybil and the one to the right of the prophet Jeremiah. Traced in the smaller sketches are the initial inspirations for the Ignudo to the right of the prophet Isaiah. Vitality, dynamic study, and originality in the pencil strokes are the unquestionable qualities of this drawing, leading the majority of critics to consider it entirely autograph. Frey and Barocchi, on the other hand, have expressed perplexity over the parts of the sheet that have been drawn over in ink.

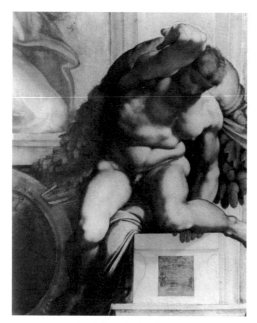

Michelangelo, detail, *Sistine Ceiling Ignudo*

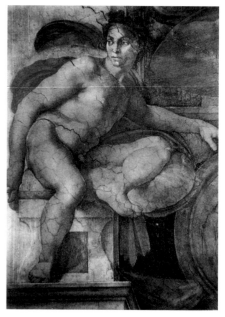

Michelangelo, detail, *Sistine Ceiling Ignudo*

Bibliography: Paola Barocchi, *Michelangelo e la sua scuola. I disegni di Casa Buonarroti e degli Uffizi*, Florence 1962, pp. 24-26, n. 15; Michael Hirst, *Michelangelo and his Drawings*, New Haven and London 1988, pp. 35 and 91; Flavio Fergonzi, in *Michelangelo nell'Ottocento. Rodin e Michelangelo*, catalog of the exhibition in Casa Buonarroti, edited by Maria Mimita Lamberti and Christopher Riopelle, Milan 1996, pp. 144-47, n. 32.

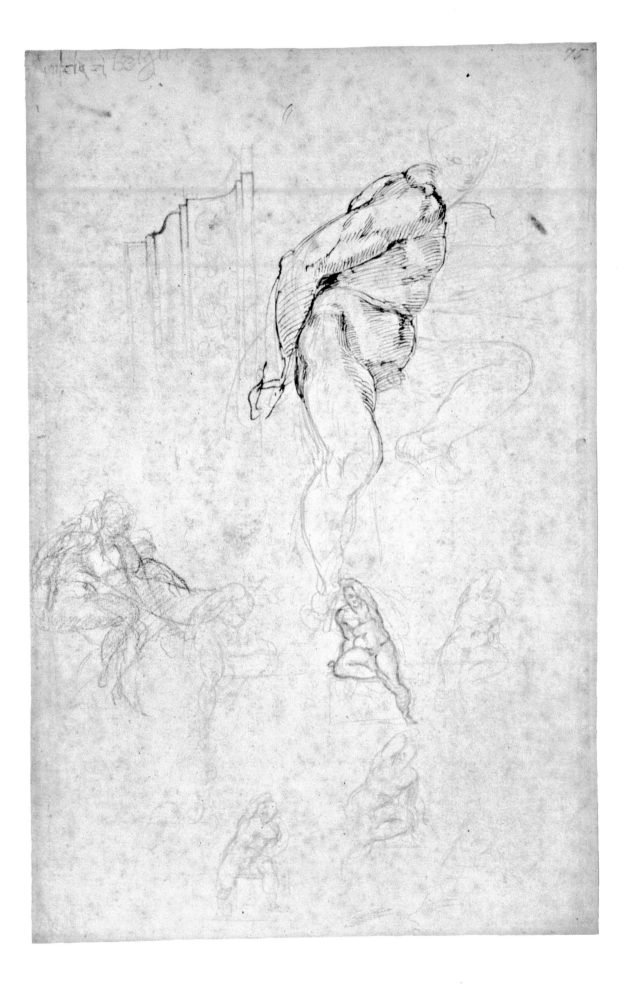

17. | MICHELANGELO
Sketches of Marble Blocks for the Tomb of Julius II, c1516
ink, 202 x 305 mm.
Inv. 67 A

Sheets such as these, which must have been part of Michelangelo's notebooks and which relate to his various building projects, are preserved in great number in the Buonarroti Archives, yet a few rare examples are inventoried in the Drawings Collection of the Casa Buonarroti.

This type of graphic essay by Michelangelo is more significant from a historical perspective than an artistic one, and the last heir of the family, Cosimo Buonarroti, often used them to make special gifts. For example, in 1827 he gave one to "secretary Gonnelli as a sign of sincere gratitude," now in the Musée Bonnat in Bayonne. There was also the one presented in honor of the marquise of Rende, Lavinio de' Medici Spada, which later became the property of the celebrated writer Stephan Zweig. Finally, the one given to Giberto VI Borromeo in 1840 as "a sampling of the character of his great ancestor Michelangelo." Today it is preserved in the Borromeo Archives of Isolabella on Lake Maggiore.

The documentary value of these papers has been underscored many times. They bear witness to Michelangelo's habit of creating rapid sketches that nevertheless included very precise indications of size for the benefit of the stonecutters. The latter must have deduced from them the shapes and dimensions of the marble blocks that the master anticipated using, insofar as these sheets sometimes became actual contracts.

Appearing in the drawing displayed here are a block of marble for a platform and three associated sketches, drawn for the most part with a ruler. They are not in perspective, thus two-dimensional, and their overall profile seems to suggest the cross-section of a kind of niche, outlined in dashed lines. Measurements and other autograph notations are inscribed within the outlines. These were recorded so that the stonecutters would know the shape and dimensions of the blocks they were to quarry. In addition, on the back of the sheet are drawn, again with a ruler, three blocks in the shape of trapezoidal solids. These are shown in perspective, and two of them include measurements. The pen marks on the back show through to the front, complicating, at least upon first glance, the reading of the image.

In the absence of chronological indications or definite references to the names of the stonecutters, the sheet has been variously connected both to the long and troubled route of the work for the tomb of Julius II in Rome (1505-45) as well as to the complicated affair surrounding the façade of San Lorenzo in Florence (1515-34). In neither case, however, does the chronological location change. In fact, Tolnay's suggestion to place it among the events relating to the papal mausoleum brings it to around 1515, that is, while Michelangelo was beginning to ponder the façade of San Lorenzo.

The drawing, which includes instructions that are merely practical, is nevertheless not without its own expressive force. The precision of the recording does not inhibit the strength of its line, which—as Paola Barocchi has pointed out—"overcoming contingency all at once, proudly offers a glimpse of the creation."

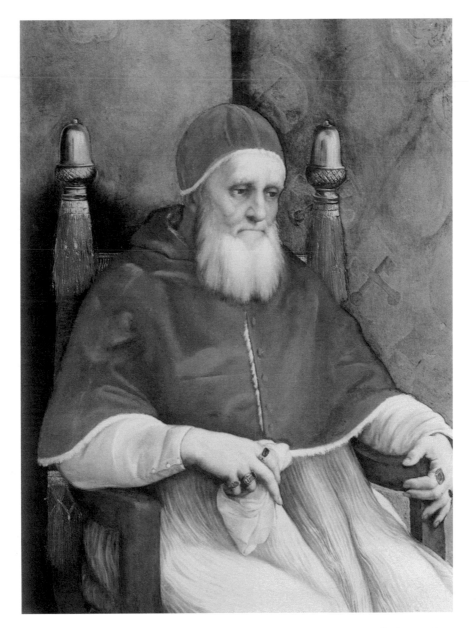

Raphael, *Pope Julius II*

Bibliography: Paola Barocchi, *Michelangelo e la sua scuola. I disegni di Casa Buonarroti e degli Uffizi*, Florence 1962, pp. 74–75, n. 53; Charles de Tolnay, *Corpus dei disegni di Michelangelo*, III, Novara 1978, pp. 98-101, nn. 460-466; Christoph Luitpold Frommel, in *Petros Eni. Pietro è qui*, catalog of the exhibition, Monterotondo 2006, p. 89, n. II.33; Mauro Natale, in *Capolavori da scoprire. La collezione Borromeo*, catalog of the exhibition, edited by Mauro Natale and Andrea di Lorenzo, Milano 2006, pp. 260-61, n. 11.

terzi puossi fare intre pezzi

pezzi a quatro

altro ombraccio e mezzo capito

coquesto uno braccio edu alterzi

Cornice farai segniato e qui disoc to

nota che io o errato ascriuere pezi tre insu lalto canto p fo ghano aessere pezzi cinque diquesto chanto e pezi cinque dellaltro chanto

braccia tre elchmanzi diquesto pezzo

67

lunga eltucto nelloggetto braccia noue edua

eldinazi de pezi decanti braciov tre
nelloguetto

nelloggecto delle riuolte
braccia dua eduva terzi

eltuiuo braccia dua e
dua terzi

braccia sette eltuiuo p lungeza

e lpiano di soprav depezzi decanti diquesta

V

e lecto
unmezo
braccio

braccia dua e mezzo dal fumo o a inluro B e eltuiuo della cornice

braccia dua mezzo ne lloguera

e lecto uno mezza braccio

e lecto di mezo braccio

pezzi tre diquesto
chanto e pezi tre
de laltro da llaltra
banda

V

Resto questo pezzo de ln
braccia tre edua terzi e o
quatro pezzi diques
diquesto delmezo

bracis tre e lalungeza diquesto pezzo
e ldinazi

18. | MICHELANGELO
Studies made from Roman Monuments, c*1515*
red pencil, *285* x *425* mm.
Inv. *1A* verso

Michelangelo, through contacts he had forged with the architect Giuliano da Sangallo at the beginning of his work on the façade of San Lorenzo in Florence, had in his hands a book of drawings with studies of the ancient world: the so-called Codice Coner, which has been convincingly attributed to Bernardo della Volpaia, a collaborator with the Sangallo family and expert in the representation of ancient architecture. This volume, preserved today in the Soane Museum in London, offers through its hundreds of plans, elevations and details arranged by type, a comprehensive overview of the principal achievements of ancient and contemporary architecture, accompanied by detailed measurements and topographical information.

In a series of sheets now divided between the Casa Buonarroti and the British Museum—which together form a coherent group on account of their similar dimensions, watermarks, techniques and subjects—Michelangelo copied about a hundred details from the Codice Coner, concentrating on the details of ornate classical decoration (trabeations, vases, capitals). Michelangelo distinguished the copies he made with a profoundly personal style, eliminating the dimensions and the annotations present on his model, and rendering his representation of the ornamental parts in a less analytical manner. Deprived of their detailed antiquarian apparatus, the ancient architectonic details attain monumentality. The free-hand use of red pencil instead of the pen employed by Bernardo della Volpaia reduces the precision of the representation but significantly increases the impact of the composition. The ancient and modern buildings from which these architectonic details are drawn may be identified without too much uncertainty on the basis of the inscriptions that appear in the Codice Coner, referring primarily to buildings in Rome and its surroundings.

For Michelangelo, this study experience, which he completed at the debut of his own activity as an architect, was not without result for his future career. It is enough to consider the obvious derivation of the windows of the New Sacristy of San Lorenzo in Florence, which are derived from the equally tapered windows of the Temple of Vesta in Tivoli that was reproduced on one of the sheets of the Codice Coner. Or—comparing, as Lotz had already done in 1967, our 1 A recto drawing with another famous drawing in the collection of the Casa Buonarroti, inventory no. 10 A, which includes sketches for pilaster bases and which relate to the planning phase of the New Sacristy—in the drawing that Michelangelo took from the Codice Coner, a striking anticipation of the profile of the base in the lower right of 10 A stands out, transformed by the artist into a human profile, perhaps a caricature of someone, no doubt screaming.

Michelangelo, *Pilaster Base for the New Sacristy, with the Artist's Handwriting*, inv. 10A

Bibliography: Wolfgang Lotz, "Zu Michelangelos Kopien nach dem Codex Coner," in *Stil und Überlieferung in der Kunst des Abendlandes*, Akten des 21 Internationales Kongresses für Kunstgeschichte in Bonn, 1964, 3 vols., Berlin 1967, II, pp.12-19; Giovanni Agosti and Vincenzo Farinella, *Michelangelo. Studi di antichità dal Codice Coner*, Turin 1987; Idem, *Michelangelo e l'arte classica,* catalog of the exhibition in Casa Buonarroti, Florence 1987, pp. 64-71; Giulio Carlo Argan and Bruno Contardi, *Michelangelo architetto*, Milan 1990, pp. 154-60.

19. | MICHELANGELO
Notice for Headmaster Andrea Ferrucci da Fiesole
April *23, 1524*
red pencil, *160* x *270* mm.
Archivio Buonarroti, I, *38* verso

Master Andrea, those men whom I have not called to work and whom you have not called either, will not be paid for the day's work.

Here is a truly unique and at the same time explicit sheet of paper. We are in the workshop of San Lorenzo, and Michelangelo writes with a red pencil a notice for the headmaster: the dimensions of the sheet and the color, size and precise and clearly legible formation of the letters in truth speak for themselves. Evidently, even though they were not hired, many came running to the workshop of the famous artist, and the notice was written about them.

Master Andrea is the sculptor Andrea Ferrucci da Fiesole, who was present for a brief time, from March 29 to June 4, 1524, in the New Sacristy of San Lorenzo. Michelangelo himself bears witness to this fact in an administrative paper: "I remember how today on the 29th day of March 1524, Master Andrea da Fiesole, a stonecutter and headmaster of the Opera di Santa Maria del Fiore, came to supervise the work on the tombs that I am making in the Sacristy of San Lorenzo, which is to say, to put the stones in front of the block cutters."

Andrea's name is often found in the Archives of the Opera del Duomo in Florence because he was put in positions of trust. Lucilla Bardeschi Ciulich cites a letter from the Opera workers dated November 26, 1523 in which we read:

> We were forced to send our headmaster Andrea up there (to the quarries of Seravezza), at our expense, sent with full authority of our entire office over the said marble blocks, and thus over the conveyors of the blocks, with power to stop and check any and all of the said labors that should please the said master Andrea.

Bibliography: I ricordi di Michelangelo, edited by Lucilla Bardeschi Ciulich and Paola Barocchi, Florence 1970, pp. 123-24, n. CXVIII, pp. 134-35, n. CXXV; *Costanza ed evoluzione nella scrittura di Michelangelo*, catalog of the exhibition in Casa Buonarroti, edited by Lucilla Bardeschi Ciulich, Florence 1989, p. 34, n. 13; Lucilla Bardeschi Ciulich, in *Michelangelo: grafia e biografia. Disegni e autografi del Maestro*, catalog of the exhibition, edited by Lucilla Bardeschi Ciulich and Pina Ragionieri, Florence 2004, p. 57, n. 18.

Maestro ādrea oueghiamini
ch io nõ o chiaman alltãuo
rare ech noghauei chia
man anch uoi nõ araimo
lagiornata

20. | MICHELANGELO
Plan for Bastions, 1527-1528
ink, brown washes, 293 x 412 mm.
Inv. 22 A

On May 17, 1527, just six days after news of the sack of Rome and the siege of Pope Clement VII in Castel Sant'Angelo reached Florence, the Florentine Republic was proclaimed and the Medici were obliged to leave the city. Florence was headed for some dramatic months, with imperial troops looming by and the scourge of a plague that caused thirty thousand deaths that summer. While the work on the New Sacristy was forcibly interrupted, Michelangelo felt the renewal of Soderini's spirit from twenty years before, which is to say from the time of the first Florentine republic. With a correspondence between his feelings and his demands as an artist and citizen that had never before appeared so resolved, Michelangelo aligned himself openly with the defense of the Republic against the imperial army that the same pope, Clement VII, had invoked to attack it.

It is necessary to keep in mind that at the beginning of the sixteenth century, Florence's ring of defensive walls was still the third communal circuit, begun at the end of the thirteenth century and erected during the course of the following one. With the advent of heavy artillery, that circuit, which reached a height of twelve meters, became obsolete and harmful because it could be easily battered down, posing a serious danger to the defenders. The use of polygonal bastions proved essential from which to attack with cannons. It was precisely the wars in Italy, beginning with the descent of Charles VIII, which demonstrated the insufficiency of the medieval defenses. Already in 1522, cardinal Giulio de' Medici posed the problem that he would face again more decisively in 1526 as Pope Clement VII. He entrusted Machiavelli and Pietro Navarra with the responsibility of devising new proposals for the defense of Florence. Because the extent of the destruction of whole sections of the city that would have resulted from his initial proposal appeared too drastic, Machiavelli proposed instead to fortify the southern zone of the city with bastions. In April 1526, the pope assigned Antonio da Sangallo the Younger to Machiavelli to begin the new defensive works.

After the expulsion of the Medici, the Republic could not help but pursue what the preceding government had begun. At this time and for this reason Michelangelo was directly called to return to the city. He was asked to join a committee called the "Nine of the Militia," and was soon named "governor and procurator general of the fortifications." Invested with such an important charge and encouraged by the respect of the citizenry and steadfast in his republican beliefs, Michelangelo elaborated a series of defense proposals for the gates of the

Michelangelo, *Design for a Fortification at the Gate of Prato d'Ognissanti*

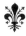

walls which, on account of their complexity and innovation, were either not built or just barely begun and today destroyed. Thus, locating his interventions has only been possible by studying the twenty-eight extraordinary sheets in the collection of the Casa Buonarroti. These plans for fortifications, already known to the court of Louis XIV because they were examined by the marquis of Vauban, have been variously cited since the beginning of the twentieth century. Yet it is necessary to come much closer to our own times to see them fully appreciated.

The drawings for fortifications in the collection of the Casa Buonarroti bear witness to various stages of Michelangelo's work. A few form part of a group of sheets that reveal some uncertainties in design and research that was not yet entirely completely worked out either from a stylistic point of view or a functional one—a situation which sometimes makes it difficult to identify to which of the eleven Florentine city gates the artist was referring. The drawing displayed here is an example of the precocious point of departure, showing how even at this point the tactical and strategic innovations of Michelangelo's thinking appear undeniable to experts. As early as 1940, Tolnay believed that our drawing 22A was dedicated to one of the southern gates of the city, identifying it as either the gate of San Miniato, San Giorgio, San Niccolò, or San Frediano, given that the enemy would necessarily come from the south.

Soon after, Michelangelo would go on to other more imaginative projects that were more specifically oriented to the purpose of fortifications, which they prefigured. Such motives were evident, for example, in the *Study for the Fortifications for Porta al Prato d'Ognissanti*, which one sees here as a comparison. In this drawing the splendid "star" of the rampart is securely located in the channel of the diverted Mugnone stream with a striking originality and a dynamic purpose that were fully coherent with the contemporary architecture of Michelangelo.

The potential practical value of these defense proposals, which contemporaries of the artist were not able to discern, does not take away from their very particular aesthetic value and their unique and expressive beauty. Argan's hypothesis is suggestive in this regard, and the historical-political judgment that follows from it is altogether realistic:

> The twenty-eight drawings for bastions in the Casa Buonarroti seem almost an incredible ex-temporal event, full of blazing fury and devastating energy. They are just plans, but they should not be regarded as preparatory studies made in view of some future construction. [Michelangelo] knew that they would never be built. There was neither the time nor the will … It would nevertheless be an error to consider those drawings as a sort of intellectual adventure composed in a state of patriotic excitement yet substantially isolated in the progress of his architectural work.

Bibliography: Paola Barocchi, *Michelangelo e la sua scuola. I disegni della Casa Buonarroti e degli Uffizi*, 2 vols., Florence 1962, I, p. 132, n. 103; Charles de Tolnay, *Corpus dei disegni di Michelangelo*, 4 vols., Novara 1975-1980, IV, p. 79, n. 570; Pietro C. Marani, *Disegni di fortificazioni da Leonardo a Michelangelo*, catalog of the exhibition in Casa Buonarroti, Florence 1984, p. 71, n. 38; Giulio Carlo Argan and Bruno Contardi, *Michelangelo architetto*, Milan 1990, pp. 145, 202-209; Giorgio Spini, *Michelangelo politico e altri studi sul Rinascimento fiorentino*, Milano 1999, p. 42; Pina Ragionieri, in *Michelangelo: grafia e biografia. Disegni e autografi del Maestro*, catalog of the exhibition, edited by Lucilla Bardeschi Ciulich and Pina Ragionieri, Florence 2004, pp. 62-63, n. 22.

❧

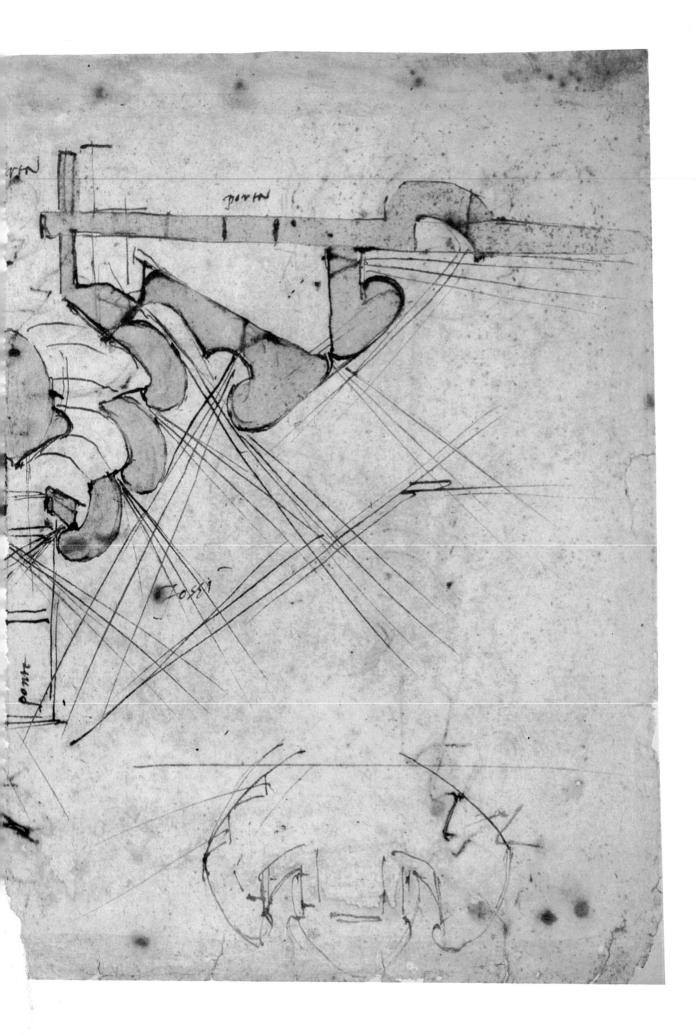

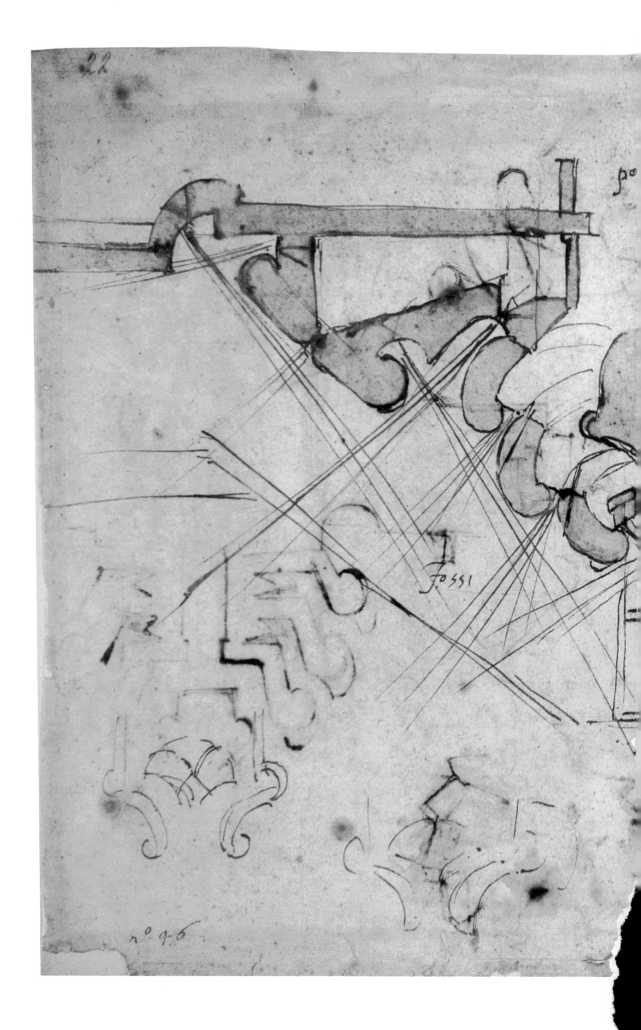

fossi

n° 7. 6.

21. | MICHELANGELO
Study for the Head of Leda, 1529-1530
red pencil, 355 x 269 mm.
Inv. 7F

This drawing is universally regarded as one of the most beautiful and important of Michelangelo's graphic production. The inclined head, portrayed in profile, hearkens back to the posture of *Night* in the New Sacristy. It shows a wonderful surety in design, rendered vibrant for its evidently having been drawn from life. Wilde, followed by the majority of scholars, was the first to suggest that Michelangelo's model was Antonio Mini, a student of the artist. We hardly need to recall the frequency with which male models were used for images of women at that time. On the other hand, we should underscore how the detail sketch of the nose and eye with long feminine eyelashes— readily seen in the lower left—refines the already very soft and pensive features of the profile. There is agreement that the sheet relates to the lost painting of *Leda*, whose story touches critical moments in the biography of Michelangelo, being interwoven with the complicated history of the dealings between Alfonso I d'Este, duke of Ferrara, and Pope Julius II.

Alfonso was hit with excommunication in the summer of 1510 for having chosen, as an adversary of Venice and ally of King Louis XII, the camp opposed to the papal alliance. Yet, just two years later, following the unexpected defeat of the French in Italy, he decided to submit himself to papal authority and went to Rome, where he obtained absolution. Three days after this event, on the 11th of July, the same Julius II permitted him to go up on the scaffolding in the Sistine Chapel, whose ceiling had by then been almost entirely frescoed by Michelangelo. The long conversation with the duke, who was ecstatic with admiration, ended with the artist promising to paint a picture for him. Many years later in August 1529, Michelangelo, then occupied with the defense of Florence against the siege of papal forces, went to Ferrara as a guest of Alfonso to study its famous system of fortifications. There Michelangelo finally let himself be persuaded to fulfill Alfonso's long-standing desire. Perhaps it was precisely the need to remain hidden following the fall of the second Florentine republic in August 1530 that permitted Michelangelo to attend to the work. Around the middle of October of that same year, the "large hall painting" was finished. Yet it never made it to Ferrara on account of the ignorance and foolishness of the envoy whom the duke had sent to collect it. Upon seeing the painting he exclaimed in the presence of the artist: "Oh, this is a small thing!" Michelangelo became very angry, and, as Condivi relates (1553, and, following in his footsteps, Vasari repeats in the Giunti edition of his *Lives*, 1568), "the ducal envoy having been dismissed, soon thereafter he gave the painting to one of his young assistants." This boy was Antonio Mini, who, together with the *Leda* seems to have received some drawings from Michelangelo and the preparatory cartoon for the painting. It is also believed, with good reason, that the work was consigned to Mini by its creator not as a gift but so that he would sell it, seeing that he had two sisters to marry. There is no question that Mini was in France between 1531 and 1532, and that the *Leda* was definitely in his possession. After Mini's death in 1533, there were still conflicting and disputed reports about the painting.

The rather complicated affair of the *Leda* was recently retraced and to large degree clarified by Janet Cox-Rearick. The scholar demonstrates, with documents at hand, that the painting undoubtedly reached Fontainebleau, although it does not appear in any royal inventory until 1683. Yet, in an inventory from 1691, an entry for the cartoon of the subject, considered to have been by Michelangelo and today in the Royal Academy in London, states, "The queen mother [Anna d'Austria] burned the painting. To be burned." According to another source, also cited by Cox-Rearick and dating to 1699, "this *Leda* was portrayed in a manner so vivid and lascivious with passionate love that M. des Noyers, a minister of state under Louis XIII, had it burned."

Reaching beyond this moralistic funeral pyre, the extraordinary invention of Michelangelo has come down to us through the numerous copies and derivations executed in the most varied techniques, among them the painting in the National Gallery of London, which is attributed to Rosso, and the large cartoon mentioned above—also attributable to Rosso—now at the Royal Academy of Arts in London. A small painting attributed to Francesco Brina, currently on display in the Casa Buonarroti, is the last evidence of the fate of the work. Important indications of its fame also remain in the field of engraving. Several examples are known, among which the most recognized are the works by Cornelis Bos and Nicolas Béatrizet. In these engravings, both rather similar, the egg and the pair of little Dioscuri (sons of Zeus) appear. Besides the swan, they are the distinctive attributes of Leda to which, by way of Michelangelo's model, the sources allude.

Bibliography: Johannes Wilde, "Notes on the Genesis of Michelangelo's 'Leda,'" in *Fritz Saxl 1890-1948. A Volume of Memorial Essays from his Friends in England*, edited by D.J. Gordon, London 1957, pp. 270-80; Mario Rotili, in *Fortuna di Michelangelo nell'incisione,* catalog of the exhibition, edited by Mario Rotili, Benevento 1964, p. 92, n. 38; Evelina Borea, in *Il primato del disegno,* catalog of the exhibition, Florence 1980, p.253, n.639; Michael Hirst, *Michel-Ange dessinateur,* catalog of the exhibition, Paris and Milan 1989, pp. 92-93, n. 38; Janet Cox-Rearick, *The Collection of Francis I: Royal Treasures,* New York 1996, pp.100, 121, 237-241; eadem, in *Venere e Amore. Michelangelo e la nuova bellezza ideale,* catalog of the exhibition, edited by Franca Falletti and Jonathan K. Nelson, Florence 2002, pp.174-77; Vincenzo Farinella *"Non si poteva satiare di guarda quelle figure." Michelangelo e Alfonso I d'Este,* in *Michelangelo. La "Leda" e la seconda Repubblica fiorentina,* catalog of the exhibition, edited by Pina Ragionieri, pp. 26-115, Cinisello Balsamo, Milano 2007; *ibid.* Pina Ragionieri, *Michelangelo e le Repubbliche fiorentine,* pp. 116-147.

Attributed to Francesco Brina (after Michelangelo), *Leda and the Swan*

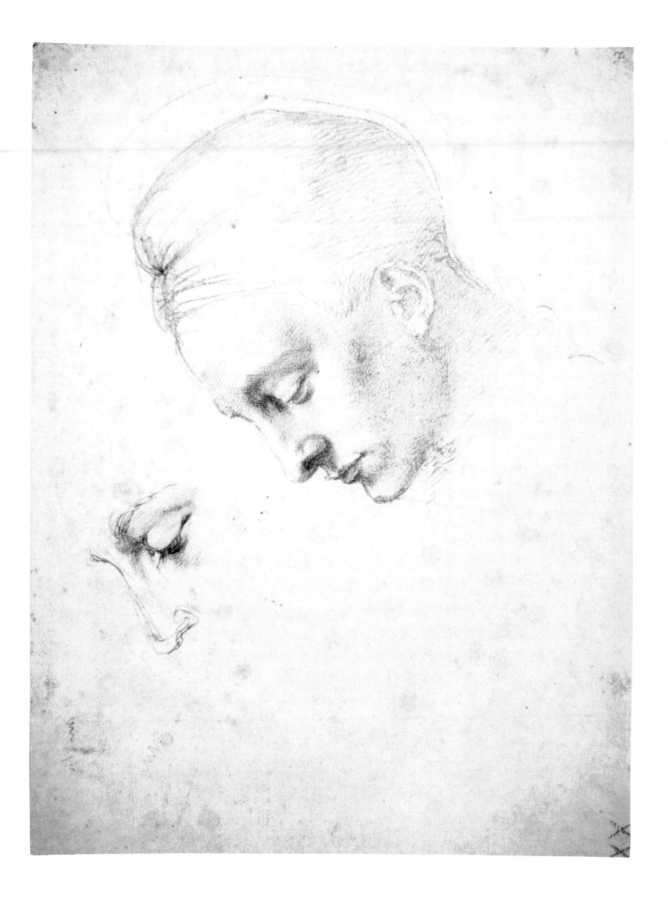

22. | MICHELANGELO
Study for a Christ in Limbo, 1530 - 1533
black pencil and red pencil, *163* x *149* mm.
Inv. *35* F

Panofsky (1927-28) and Dussler (1957) denied that this is an autograph drawing, agreeing upon an attribution to Antonio Mini which today, in light of authoratative critical opinions, is difficult to accept. It is now maintained that the sheet may be one of the latest witnesses to the relationship that transpired between Michelangelo and the Venetian painter Sebastiano del Piombo, who arrived in Rome at the beginning of the 1520s. On more than one occasion, Michelangelo provided drawings to Sebastiano to guide him in the realization of his paintings. The results of this generous help are, among others, the famous *Flagellation* in the Borgherini chapel in San Pietro in Montorio in Rome and the *Resurrection of Lazarus*, which is preserved in the National Gallery in London.

It seems that Sebastiano profited from this dramatic sketch by Michelangelo for a *Christ in Limbo* for one of his own works on the same subject, completed at the beginning of the 1530s and currently displayed at the Prado Museum. If one accepts this hypothesis, advanced by Thode and by Goldsheider and taken up more recently by Hirst, the drawing cannot be dated much later than the beginning of the 1530s, when the long friendship between Michelangelo and Sebastiano was forever broken. As Vasari relates in the *Life* of the Venetian painter: "… having to paint the façade of the pope's chapel [that is, the rear wall of the Sistine Chapel, where the *Last Judgment* would be painted] … there was between them quite a bit of contemptuousness, Fra' Sebastiano having persuaded the pope to make Michelangelo do it in oil, there, where he did not want to do it if not in fresco," declaring "coloring with oils is an art for women and for aged and infirmed people like Fra' Bastiano." Documentary evidence produced by Paola Barocchi among others confirms the truthfulness of this conflict and its duration almost until Sebastiano's death.

Barocchi disputes, however, the legitimacy of the comparison, underlining that the figure of Christ appears reversed in the painting at the Prado and the scene is quieter. The tumultuous force that runs through the whole drawing disappears, involving the well-defined protagonist and secondary figures that are rapidly traced in red and black pencil. It is precisely this extraordinarily vigorous marking that leads one to think of the theme of the Resurrection of Christ, which captured the attention of Michelangelo for no short time—a period that Wilde placed in the years 1532-33, which is eloquently exemplified in the beautiful preliminary drawing in the Louvre (inv. 691 bis.).

The various suggestions that have been put forward for this masterpiece nevertheless tend toward the same dating, which is also convincing from a stylistic point of view, insofar as we are close to the initial plans for the *Last Judgment*.

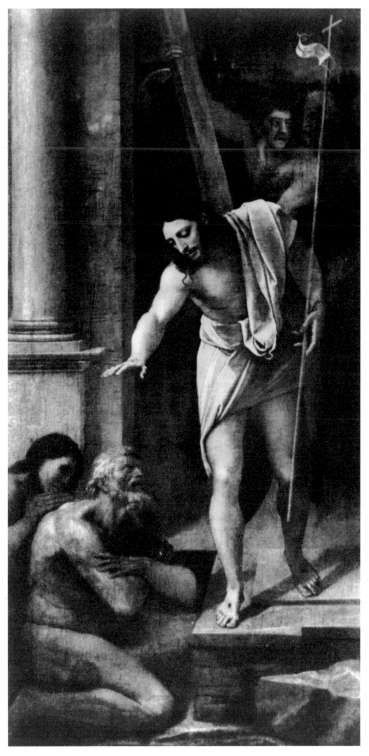

Sebastiano del Piombo, *Christ in Limbo*

Bibliography: Paola Barocchi, *Michelangelo e la sua scuola. I disegni di Casa Buonarroti e degli Uffizi*, 3 vols., Florence 1962, I, pp.168-69, n.135; Charles de Tolnay, *Corpus dei disegni di Michelangelo*, 4 vols., Novara 1975-1980, I, p.82, n.90; Mauro Lucco, in *L'opera completa di Sebastiano del Piombo*, Milan, 1980, p.106, n.44; Michael Hirst, *Sebastiano del Piombo*, Oxford 1981, pp.129-30; Paul Joannides, in *L'ombra del genio. Michelangelo e l'arte a Firenze 1537-1631*, catalog of the exhibition, edited by Marco Chiarini, Alan P. Darr and Cristina Giannini, Milan, 2002, pp.319-21, n.186.

35

23. | MICHELANGELO
Three Nudes, 1531-1532
black pencil, ink, *178* x *209* mm.
Inv. *38*F

The following nineteenth-century inscription appears on the reinforced backing of this drawing: "Ideas for the Expulsion of Adam and Eve in the Sistine [Chapel]"—an enticing reference, no doubt, yet one that until now has never been published. Scholars moreover have considered only the three figures drawn in pen in the lower right while the sheet is strewn with other sketches in pencil that are difficult to capture with a camera yet are discernable upon careful examination of the original.

Drawing 38 F undoubtedly constitutes—together with four studies in pen that also belong to the collection of the Casa Buonarroti (inv. 17 F, 18 F, 67 F, 68 F) and a sheet in the Ashmolean Museum in Oxford—a unified group for which various opinions about its dating and purpose have been expressed without, however, questioning their attribution to Michelangelo. If nothing else, scholars agree upon regarding these drawings as suggestions that Michelangelo offered to his artist friends. In this regard, we remember that according to the sincere legend of the artist, he had a rather special manner of displaying generosity to his friends. From the time that he was a youth, we find him committed to giving cartoons and models to those who were close to him—an unmistakable golden thread that runs throughout Michelangelo's whole career. He passed along wonderful creations both to great artists, like Sebastiano del Piombo and Pontormo, as well as to minor figures to whom he was bound by relationships of personal benevolence.

Some critics relate this nucleus of drawings to the *Transfiguration* that was commissioned from Sebastiano del Piombo in 1516 for the Borgherini Chapel in the church of San Pietro in Montorio in Rome. Other scholars connect it instead to the *Martyrdom of Saint Catherine* executed by Giuliano Bugiardini for the church of Santa Maria Novella in Florence. Both artists were bound to Michelangelo through long friendship, although at rather different levels. In the great Venetian artist Sebastiano Luciani, who came to Rome in 1511 and was later called "del Piombo" for his having assumed the office of the papal sealer in 1531, Michelangelo found a valuable ally in the rivalry that opposed him to the party of Raphael and his followers. With Bugiardini, on the other hand, his relationship was based upon a friendship born in their adolescence that had continued uninterrupted though the intervening years. As discussed at greater length in the introduction to the first section of this catalog, it was none other than Bugiardini who would portray Michelangelo at work in one of the few images of the artist made from life.

Precise correspondences do not exist between the figures sketched in this group of sheets and those which appear in the *Transfiguration* and the *Martyrdom of Saint Catherine.* However, as Henry Thode first suggested, a connection to the large painting in Santa Maria Novella seems more plausible. It is enough to observe that in the lunette by Sebastiano in San Pietro in Montorio, the three motionless apostles who watch the revelation of the divine nature of Christ are placed two at the extreme left of the scene and one on the extreme right. On the contrary, in Michelangelo's sketches, the figures are pictured huddled together and struck by violent agitation. An expressive situation of this type suits better the anguished soldiers who occupy the foreground of Bugiardini's altarpiece, in which the angel who frees Catherine from the torture wheel gives rise to a series of emotional

reactions. Vasari recalls Michelangelo's involvement in this undertaking, which was commissioned from Bugiardini by Palla Rucellai and destined from the beginning for the chapel owned by the family in Santa Maria Novella. Work on the altarpiece, which was finished around 1540, kept its creator busy for more than twelve years. In addition to Michelangelo, the sculptor Nicolò Tribolo also came to Bugiardini's aid, providing him with three-dimensional models in order that he might better study the diffusion of light and shadows.

Michelangelo's collaboration, which, once again according to Vasari, also included direct intervention on the altarpiece, must be placed chronologically before the artist's definitive relocation to Rome, which occurred in September 1534. Pointing in this direction are the obvious similarities between the figures of the soldiers in the foreground in Bugiardini's altarpiece and some of the figures of the *Last Judgment* in the Sistine Chapel, for which Michelangelo was commissioned in the spring of 1534 when he was still in Florence.

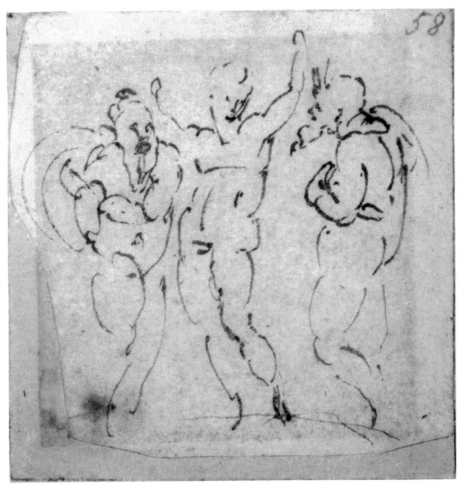

Michelangelo, detail, *Studies of figures for the Transfiguration*

Bibliography: Johannes Wilde, *Italian Drawings in the Department of Prints and Drawings in the British Museum. Michelangelo and his Studio,* London 1953, pp. 86-87; Paola Barocchi, *Michelangelo e la sua scuola. I disegni di Casa Buonarroti e degli Uffizi,* Florence 1962, pp. 155-60, nn.125-29; Michael Hirst, *Sebastiano del Piombo,* Oxford 1981, pp. 58-59; Laura Pagnotta, *Giuliano Bugiardini,* Turin 1987, pp. 70-72, 222-223, n. 70; Tullia Carratù, in *Disegni di Leonardo, Michelangelo, Raffaello,* catalog of the exhibition, edited by Claudio Strinati, s.l. 2002, pp. 94-95, nn. M.10-13.

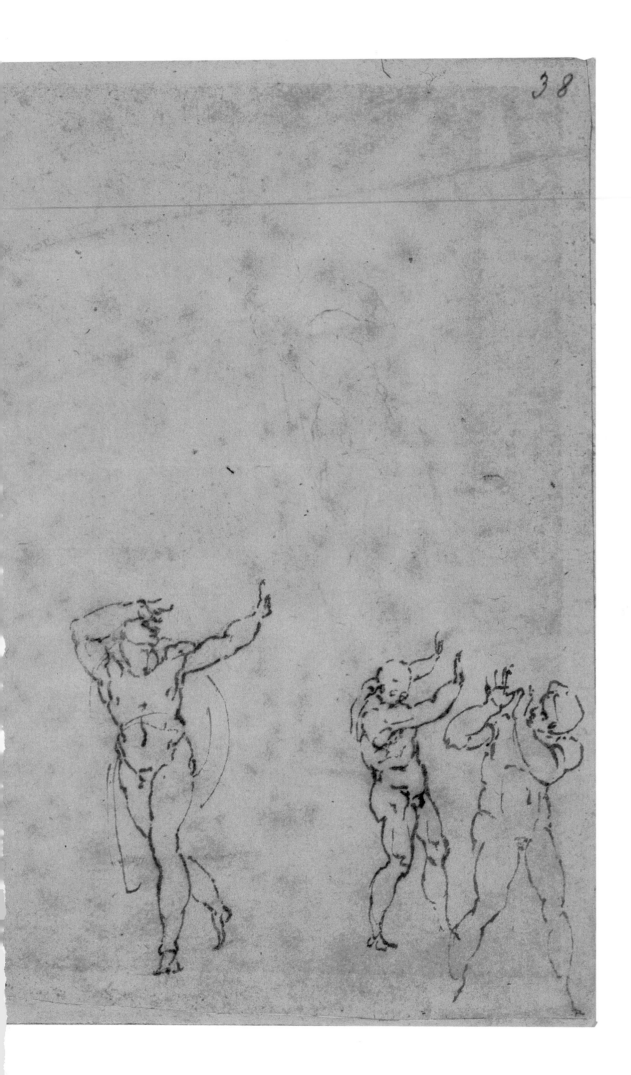

24. | MICHELANGELO
Sacrifice of Isaac, c*1535*
black pencil, red pencil, ink, *482* x *298* mm.
Inv. *70* F

"One of the most interesting of Michelangelo's mature sketches" is how Berenson characterized this drawing. He continued: "Black chalk is used with a master's freedom, every touch telling, no fumbling, no indecision, nothing over-elaborated and nothing omitted." The sheet has always been considered autograph, except by Baumgart and Panofsky, who proposed the name of Daniele da Volterra without, however, finding any following.

This piece, which is without a doubt one of the masterpieces of the collection of Michelangelo's drawings at the Casa Buonarroti, cannot be connected with works or plans of the master. The sole scholar to advance hypotheses in this direction was Tolnay, who placed it in relation to the reliefs that were to have decorated the tombs of the Medici popes Leo X and Clement VII that were intended for the chancel of the basilica of San Lorenzo in Florence—tombs which otherwise were never executed. The supposition was founded upon the close examination of a drawing of Michelangelo, now in Christ Church, Oxford (inv. 0993 r.), which represents the design of a papal tomb. In the upper right of the drawing there appears a tondo containing a *Sacrifice of Isaac*. From this, Tolnay prematurely dates the drawing to the years in which Michelangelo was occupied with the construction of San Lorenzo (1524-26).

Filippo Brunelleschi, detail, *Sacrifice of Isaac*

In reality, the chronological placement of the sheet remains in controversy. One begins with the proposal of Steinmann, who thought it was from the time of the Sistine vault, and proceeds to the idea of Dussler, who pushed it later than the *Last Judgment*. The majority of scholars, however, hold a different opinion, among them Berenson and Paola Barocchi, who date the work toward the middle of the 1530s. In fact, the entwining stroke of the drawing, which is completely legible despite certain later retouchings, reveals a mature phase and seems to foreshadow the tormented movement of the *Last Judgment*. The dating accepted here is based upon such stylistic resonances.

It is nevertheless peculiar that in reference to our 70 F, the obvious recollection of Filippo Brunelleschi has never been noted. A comparison with the famous panel from the competition of 1401 for the second door of the Baptistery in Florence in fact reveals analogies that are so numerous and so significant to make this drawing, if not a copy of the panel by Brunelleschi, then certainly an homage to an artist whom Buonarroti greatly admired.

The inscription "by Michelangelo" was added to the foot of the sheet by his grandnephew Michelangelo Buonarroti the Younger.

Bibliographhy: Paola Barocchi, *Michelangelo e la sua scuola. I disegni di Casa Buonarroti e degli Uffizi*, 3 vols., Florence 1962, I, pp. 174-175, n. 140; Charles de Tolnay, *Corpus dei disegni di Michelangelo*, 4 vols., Novara 1975-1980, II, pp. 80-81, n. 283; Paul Joannides, *Dessins Italiens du Musée du Louvre. Michel-Ange. Élèves et copistes*, Paris 2003, p. 131.

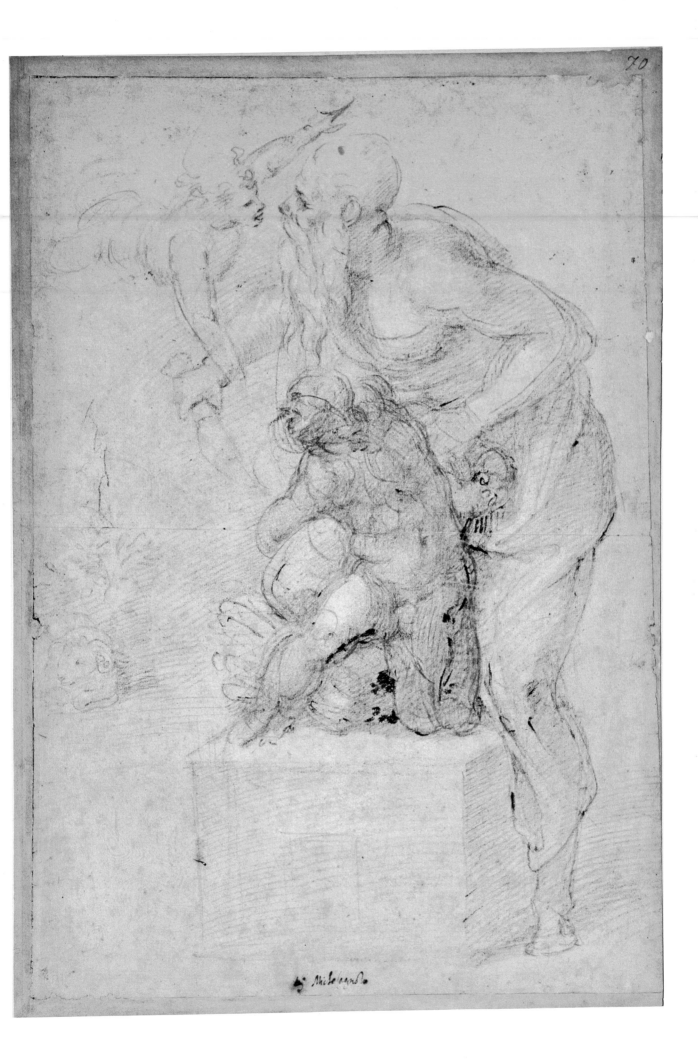

25. | MICHELANGELO
Plan for San Giovanni dei Fiorentini, 1559-1560
black pencil, red pencil, and brown washes, *417* x *376* mm.
Inv. *124* A

In 1559, at the age of eighty-four, Michelangelo was persistently entreated to provide a plan for the church of the Florentine nation in Rome. It was to have been erected between the banks of the Tiber River and the Via Giulia, and dedicated to St. John, the patron saint of Florence, and to saints Cosmas and Damian, the patron saints of the Medici family. The church had already been designed by Sansovino and Antonio da Sangallo, but at the time the request was put to Buonarroti, only the foundations had been laid. The idea, born in the era of Medici pope Leo X, now had the support of the duke of Florence, Cosimo I de' Medici, as witnessed by a letter from Michelangelo to the duke dated November 1, 1559, in which the aged artist eloquently sums up the situation:

> Most illustrious Sir, duke of Florence, the Florentines have already many times expressed their greatest desire to establish here in Rome a church dedicated to St. John. Now, hoping that your Lordship will find it more convenient, five men have taken charge of this project. They have asked many times and begged me to design the said church. Knowing that Pope Leo had already begun the said church, I responded to them that I did not want to pursue it without the license and commission of the duke of Florence. Now, as it happened to occur, I received a letter from your very benign and gracious and Most Illustrious Lordship, which I take as an express order that I must attend to the above-mentioned church of the Florentines, showing that I have the greatest pleasure in doing so."

Michelangelo goes on, affirming that he has already executed a few designs, and that he has found a capable assistant who can draw "more precisely than I could have on account of old age.

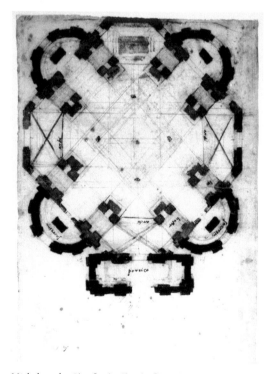

Michelangelo, *Plan for the Church of San Giovanni dei Fiorentini*

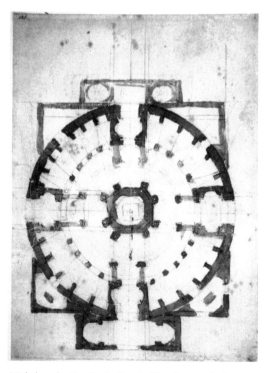

Michelangelo, *Plan for the Church of San Giovanni dei Fiorentini*

He concludes: "Woe be unto me in case if I should be so old and so disagreeable with life that I can hardly promise myself for the said construction. Rather I will strive hard, staying at home, to do that which will be asked of me on behalf of your Lordship, and may God will that I lack nothing for that."

Vasari affirms that for the occasion, Michelangelo prepared "five plans for beautiful temples"—and there are exactly five drawings at Casa Buonarroti that are dedicated to full or partial plans for San Giovanni dei Fiorentini. The splendid drawing displayed here represents the finished phase of the project. In the center, there is an altar surrounded by eight pairs of columns and four chapels in the corners. This is the plan that was selected and from which Tibero Calcagni, a student of the artist, traced a copy to present to duke Cosimo in 1560. Our drawing 124 A shows how Michelangelo would modify his own plans little by little as he went forward with his designs. In fact, the blackish appearance of several parts of the plan, so different than the central portion with the main altar, shows the points where the Master corrected and recorrected, going over it with pen and brush while the white lead paint was still wet. The complex construction of this plan appears to have been realized from a series of circles made with a compass, of which traces are still visible.

Michelangelo's plan for San Giovanni dei Fiorentini was never realized. The construction of the church, which is still standing, was begun in 1583 by Giacomo della Porta, who used a plan based on a Latin cross. It was finished only in 1614 with the intervention of Carlo Maderno.

Bibliography: *Il carteggio di Michelangelo*, edited by Paola and Renzo Ristori, 5 vol., Florence 1965-83, V, pp.183-184; Michael Hirst, *Michel-Ange dessinateur*, catalog of the exhibition, Paris and Milan 1989, pp. 156-57, n. 62; Hubertus Günther, in *Rinascimento. Da Brunelleschi a Michelangelo - La rappresentazione dell'architettura*, catalog of the exhibition, edited by Henry A. Millon and Vittorio Magnago Lampugnani, Milan 1994, p. 473, n. 71.

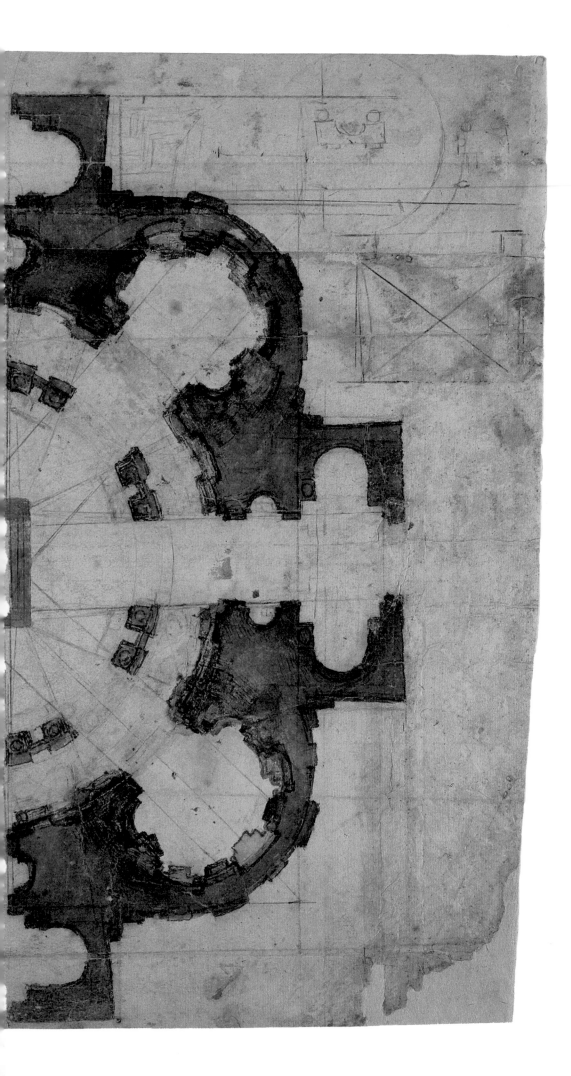

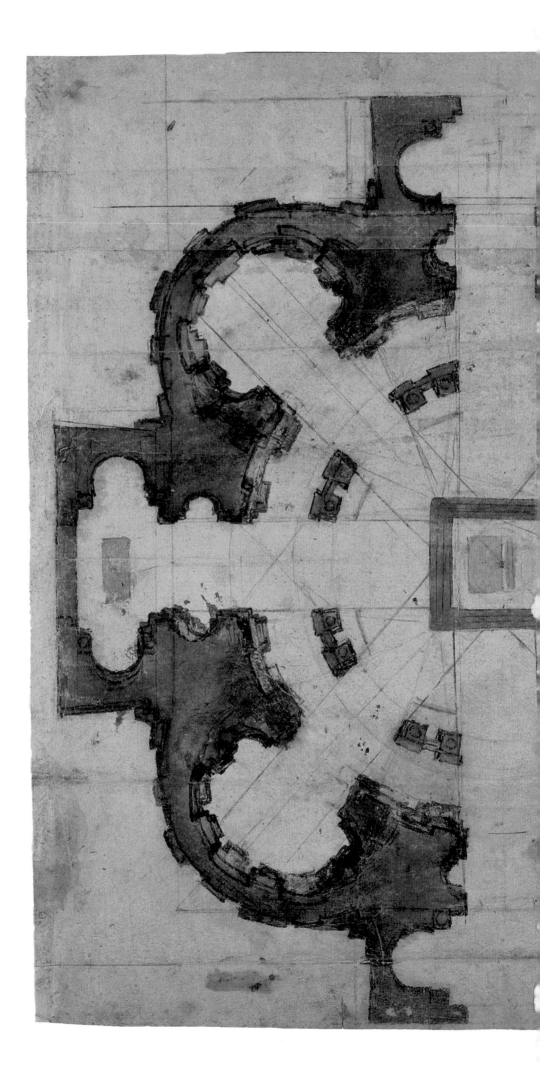

26. | MICHELANGELO
Study for a Gate (Porta Pia?), 1561
black pencil, brown watercolor wash, *399* x *269* mm.
Inv. *73* A bis

Urban renovation projects commissioned by Pope Pius IV for the creation of a new street in Rome, the "Via Pia," date from between the end of 1560 and the beginning of the following year. The new street was to connect Monte Cavallo to the Aurelian walls. At the end of its route, a new gate was to have opened in the ancient walls, between the Porta Salaria and the Porta Sant'Agnese. For the design, the pope entrusted himself to Michelangelo, who had by then reached the age of 86. The artist dedicated himself passionately to the commission, from which numerous drawings have come down to us, both of large dimension (as shown here) and small. Vasari provides valuable information about the conceptual phase of the project:

> Being sought out by the pope at this time for a drawing for the Porta Pia, Michelangelo made three, all very extragavant and beautiful, such that the pope decided to proceed with the construction of the one that would cost the least, as one sees it today built with many praises for him. And seeing the pope's good humor, he made many other drawings for him so that he might restore the other gates of Rome.

The drawing displayed here is part of a large cluster of sheets preserved in various collections that are related to the conceptualization of the Roman gates. The attribution of the sheets to Michelangelo has been generally accepted by critics, especially recently, after some skepticism on the part of scholars during the first half of the twentieth century. Bruno Contardi, following Paola Barocchi and Michael Hirst among others, includes this sheet in a series of studies by Michelangelo that are dedicated to the conceptualization of the Porta Pia, even though he does not exclude the possibility that it might pertain to another of the gates that Michelangelo designed for Pius IV.

Hirst proposes a convincing stylistic reading of the drawing, on the basis of which he goes on to affirm that Michelangelo would have begun to work on it with the intention of offering the pope a true and proper "model." The composition, however, remained unfinished. The successive projects for the Porta present more complicated solutions, frequently characterized by an increasingly generous use of the brush, no doubt determined by his pursuit of extraordinary chiaroscuro effects—yet also, perhaps, as a convenient expedient for the artist to cover up pencil marks that were made unsteady by his now very advanced age.

Bibliography: Giorgio Vasari, *La vita di Michelangelo nelle redazioni del 1550 e del 1568*, edited with commentary by Paola Barocchi, Milan and Naples 1962, I, p. 111; Paola Barocchi, *Michelangelo e la sua scuola. I disegni di Casa Buonarroti e degli Uffizi*, Florence 1962, p. 205, n. 164; Charles de Tolnay, *Corpus dei disegni di Michelangelo*, IV, Novara 1980, p. 109, n. 615; Michael Hirst, *Michel-Ange dessinateur*, catalog of the exhibition, Paris 1989, pp. 159-160; Giulio Carlo Argan, Bruno Contardi, *Michelangelo architetto*, Milan 1990, pp. 350-353; Cammy Brothers, in *Michelangelo e il disegno di architettura*, catalog of the exhibition, edited by Caroline Elam, Venice 2006, pp. 207-209, n. 23.

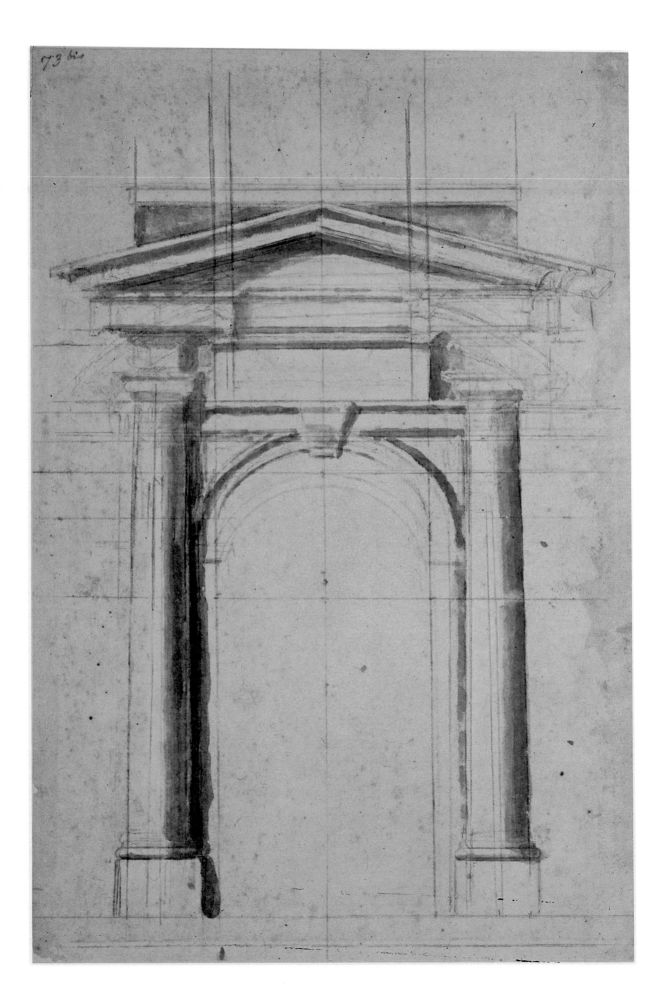

27. | MICHELANGELO
Pietà, original design *1499*
cast replica *1982*
bronze, *170* x *170* x *91* cm.
cast by Fonderia Marinelli
courtesy of Tod Tarrant, President, Tableau Fine Art Group

"The rarest artist could add nothing to its design and grace, or finish the marble with such polish and art, for it displays the utmost limits of sculpture. Among its beauties are the divine draperies, the foreshortening of the dead Christ and the beauty of the limbs with the muscles, veins, sinews, while no better presentation of a corpse was ever made. The sweet air of the head and the harmonious joining of the arms and legs to the torso, with the pulses and veins, are marvellous, and it is a miracle that a once shapeless stone should assume a form that Nature with difficulty produces in flesh."

From Giorgio Vasari, *Lives of the Artists*, first published 1550, 2nd edition 1568.

There are probably only a few works of Christian art that may be better known than Michelangelo's *Pietà*. History, myth, and recent events have added to its mystique. Older Americans will remember the fact that the original marble sculpture traveled to America as part of the Vatican Pavilion exhibition at the New York World's Fair in 1964 and 1965. Others may remember a random act of vandalism during the 1970s that forced Vatican authorities to place the sculpture behind inches of bullet-proof glazing.

Historians of art, especially those that specialize in Italian Renaissance, consider this sculpture as a landmark in Michelangelo's career. Begun in 1498 when he received a commission to "make a Pietà of marble...a Virgin Mary clothed with the dead Christ in her arms," Michelangelo took two years to complete the commission. The source of this commission was Cardinal Jean de Bilhères de Lagraulas (Jean de Villers de la Grolaie,) abbot of St. Denis near Paris, who was the ambassador of King Charles VIII to the papal court of Pope Alexander VI. Also known as the Cardinal di San Dionigi, Lagraulas was interested in finding a suitable sculpture for his memorial chapel.

The cardinal entrusted the securing of the commission to a friend and benefactor of Michelangelo, Jacopo Gallo, who had previously acquired a marble Bacchus from the Florentine sculptor. In addition to outlining the schedule of payments to Michelangelo, the contract stipulated that the sculpture was to be life-size, made of marble, and that it should be completed in one year. Additionally, Gallo took on several obligations of his own including the very presumptuous assurance that the sculpture would "be more beautiful than any work in marble to be seen in Rome today." Considering the discoveries of Roman antiquities, this was indeed a bold statement.

The actual completion of the commission took almost two years, rather than one, and Michelangelo's patron did not live to see its completion. Upon its completion the sculpture was placed in a chapel of the church of Santa Petronilla. This was a very old, possibly 4th century building, that had become a mausoleum for French royals. After the enlargement of St. Peter's Basilica began the *Pietà* was removed to the chapel of the *Virgin of the Fever* or *Santa Maria della Febbre*. In fact, this name became synonymous with the *Pietà* which is recorded in many documents as the *Madonna della Febbre*. The

sculptural group has been moved several times in its history, but for the last 250 years has resided in its present location in the first side chapel along the right side of the nave of St. Peter's.

The bronze replica in this exhibition, one of an edition of twelve, was cast by the Marinelli Foundry of Florence, Italy, and was made from a mold authorized by Vatican officials in 1932. Reproduced in the exact size of the original marble sculpture, this bronze was cast in 1982.

Among others, the foundry has cast replicas of Lorenzo Ghiberti's Doors (also known as the *Gates of Paradise*) for the Baptistery of San Giovanni in Florence, the *Porcellino* sculpture from the straw market in Florence, and several copies of Michelangelo's *David*. They are presently working on a replica of Ghiberti's *St. Matthew* that will replace the original bronze located at the Church of Orsanmichele.

[D.I.]

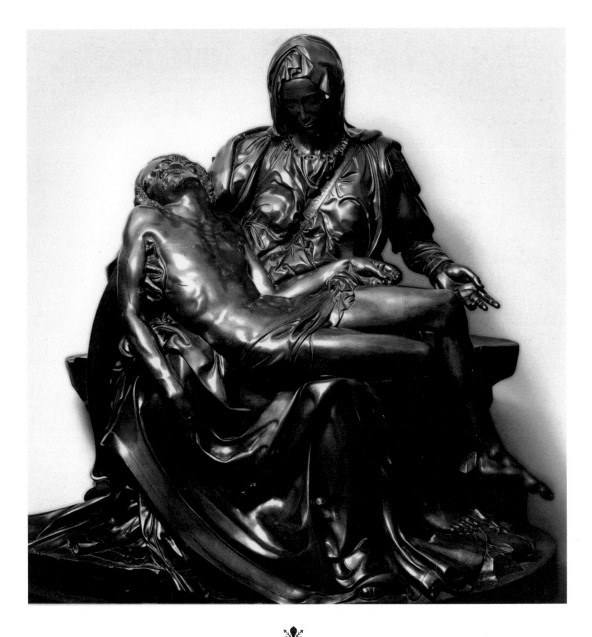

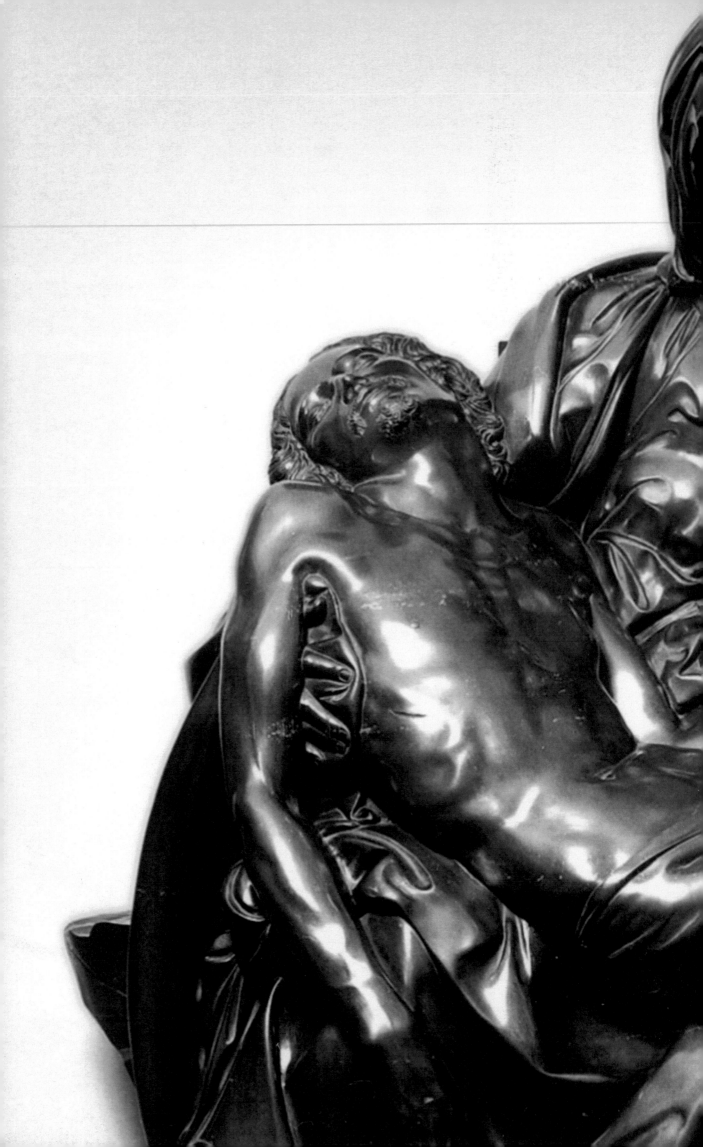

Die xxvi. mensis Augusti 1498 / 1.

Sia noto e manifesto a chi legera la presente scripta come el R.mo Cardinal
di San dionisio sie convenuto con Maestro Michelangelo Stataruario
fiorentino che lo dito maestro debia far vna pieta di Marmo
a sue spese cioe vna Vergine Maria vestita con Xpo morto
in braccio grande quanto sia vno homo justo per preczo de du-
cati Quattrocento Cinquata doro in oro papali in termino di vno
Anno dal di dala principiata opera Et lo dito R.mo Car.le
promette farli lo pagnimeto in questo mo Cioe

Imprimis promette dareli du- Cento cinquata doro in oro papali
finati che comezi Lopera

Et da poi principiata lopera promette ogni quattro mesi dareli du-
cento simili al dito Michelangelo In mo che li diti Quattrocento
Cinquata du- doro in oro papali siano finiti di pagarli in vno
Anno sela dita opera sera finita et se prima sera finita
che la sua R.ma prima sia obligata a pagarlo del tutto.

Et Io Jacobo gallo promette al R.mo mons re che lo dito Michelangelo fara
la dita opera jnfra vno anno e sera la piu bella opera
di Marmo che sia hoge in Roma che maestro nisuno la faria
megluor hoge Et p sua vice promette al dito Michelangelo
che lo R.mo Car. la fara lo pagnimeto segundo che d sopra
e scripto, Et a fede Io Jacobo gallo ho fatta la presente di mia
propia mano Anno mese e di sopredeto promendosi p questa
scripta esser Cassa e annullata ogni altra scripta di mano
mia o vo di mano del dito Michelangelo e questa sola habia effecto
havendo el dito R.mo Car.le a mo Jacobo puo tto da du- Cento doro in oro di
Camera e e di diti du- Cinquata doro in oro papali.

Ita est Io card.le S. Dyonisii Idem Ja. gallus manu ppria

Copy

AUGUST 7, 1498

Be it known and manifest to all who shall read this present writing that the Most Reverend Cardinal di San Dionisio has agreed that Maestro Michelangelo, sculptor of Florence, that the said Maestro shall at his own proper costs make a Pietà of marble; that is to say, a draped figure of the Virgin Mary with the dead Christ in her arms, the figures being life-size, for the sum of four hundred and fifty gold ducats in papal gold to be finished within the term of one year from the beginning of the work. And the Most Reverend Cardinal promises to pay the money in the manner following:

that is to say, he promises to pay the sum of one hundred and fifty gold ducats in papal gold before ever the work shall be begun,

and thereafter while the work is in progress he promises to pay to the aforesaid Michelangelo one hundred ducats of the same value every four months, in such wise that the whole of the said sum of four hundred and fifty gold ducats in papal gold shall be paid within a twelvemonth, provided that the work shall be finished within that period: and if it shall be finished before the stipulated term his Most Reverend Lordship shall be called upon to pay the whole sum outstanding.

And I, Jacopo Gallo, do promise the Most Reverend Monsignor, that the said Michelangelo will complete the said work, within one year, and that it shall be more beautiful than any work in marble to be seen in Rome today, and such that no master of our own time shall be able to produce a better. And I do promise the aforesaid Michelangelo, on the other hand, that the Most Reverend Cardinal will observe the conditions of payment as herein set forth in writing.

And in token of good faith I, Jacopo Gallo, have drawn up the present agreement with my own hand the year, month and day aforesaid. Furthermore, be it understood that all previous agreements between the parties drawn up by my hand, or rather, by the hand of the aforesaid Michelangelo, are by this present declared null and void, and only this present agreement shall have effect.

The said Most Reverend Cardinal gave to me, Jacopo Gallo, one hundred gold ducats of the chamber in gold some time ago, and on the aforesaid day as above set forth I received from him a further sum of fifty gold ducats in papal gold.

Ita est IOANNES, CARDINALIS S. DYONISII
Idem Iacobus Gallus, *manu proprio*

EXHIBITION CHECKLIST

THE FACE OF MICHELANGELO

1) Workshop of the Opificio delle Pietre Dure
Monument to Michelangelo, 1874
alabaster and precious stones, 57 cm.
Florence, Casa Buonarroti, inv. 625

2) Marcello Venusti (Como c1515-Rome 1579)
Portrait of Michelangelo, post-1535
oil on canvas, 36 x 27 cm.
Florence, Casa Buonarroti, inv.188

3) Giorgio Ghisi (Mantua 1520-1582)
Portrait of Michelangelo, 1545-1565
engraving, 268 x 212 mm.
Florence, Casa Buonarroti inv. 785

4) Leone Leoni (Arezzo 1509-Milan 1590)
Medal of Michelangelo, 1560-1561
lead, diameter 61 mm.
Florence, Casa Buonarroti, inv. 611

5) Michelangelo
Se dal cor lieto divien bello il volto, c1544
madrigal
pen, 255 x 183 mm.
Florence, Archivio Buonarroti, XIII, 46

6) Michelangelo
Four epitaphs in honor of Cecchino Bracci
sent to Luigi del Riccio, 1544
pen, 216 x 230 mm.
Florence, Archivio Buonarroti, XIII, 33

7) *Rimes of Michelagnolo Buonarroti, collected by his*
nephew Michelagnolo
Florence, 1623
Florence, Casa Buonarroti, Biblioteca, B.464.R.

8) Filippo Morghen (Florence 1730- after 1807)
Giovanni Elia Morghen (Florence 1721-after 1789)
Based on the design of Joseph Chamant (Haraucourt
1699-Vienna 1768)

"Tomb of the Great Michel Agnolo Buonarroti in
Santa Croce in Florence", 1746 (?)
engraving, 282 x 198 mm.
in Ascanio Condivi, *Vita di Michelagnolo Buonarroti …,*
second edition, corrected and enlarged, Florence,
Gaetano Albizzini, 1746.
Florence, Casa Buonarroti, Biblioteca, B.738.R.G.F.

9) Francesco Bartolozzi
(Florence 1727-Lisbon 1815)
Portrait of Michelangelo, c1802
engraving, 330 x 245 mm.
In Richard Duppa, *The Life and Literary Works of Michel*
Angelo Buonarroti
London, John Murray et al., 1806
Florence, Casa Buonarroti, Biblioteca, B.993

10) *Le rime di Michelangelo Buonarroti pittore, scultore*
e architetto cavate dagli autografi e pubblicate da Cesare
Guasti Accademico della Crusca
(The Poetry of Michelangelo painter, sculptor and architect
transcribed from the original documents and published by
Cesare Guasti Accademico della Crusca)
Florence, 1863

11) *Die Dichtungen des Michelagniolo Buonarroti*
(The Poems of Michelangelo Buonarroti)
edited by Carl Frey with an engraved portrait of
Michelangelo by Francisco de Hollanda
Berlin, 1897
Florence, Casa Buonarroti, Biblioteca, B.490

12) Ernst Steinmann
(Jördenstorf 1866-Basel 1934)
Die Portraitdarstellungen des Michelangelo
(The Portrait Representations of Michelangelo)
Leipzig, 1913
(open to pages 94-95, with the reproduction of
the portrait print of Michelangelo by Francesco
Bartolozzi)
Florence, Casa Buonarroti, Biblioteca, B.1479.G.F.

Michelangelo, detail, *Sacrifice of Isaac*

13) *The Sonnets by Michael Angelo Buonarroti*
translated into rhymed English by
John Addington Symonds (Bristol 1840-Rome 1893)
Venice, 1906
Florence, Casa Buonarroti, Biblioteca, B.463
(open to pp. 48-49; on p. 48, Michelangelo
portrays Vittoria Colonna)

14) E. Benjamin Britten (1913-1976)
Seven Sonnets of Michelangelo, op.22,
Set to Music for Tenor Voice and Piano
London 1943

DRAWINGS BY MICHELANGELO FROM THE CASA BUONARROTI

15) Michelangelo
Crested Head, 1503-1504
ink, 75 x 56 mm.
Florence, Casa Buonarroti, inv. 59 F

16) Michelangelo
Studies for a Cornice and for the Nudes for the Sistine Ceiling, 1508-1509
black pencil, ink, 414 x 271 mm.
Florence, Casa Buonarroti, inv.75 F

17) Michelangelo
Sketches of Marble Blocks for the Tomb of Julius II, c1516
ink, 202 x 305 mm.
Florence, Casa Buonarroti, inv. 67 A

18) Michelangelo
Studies made from Roman Monuments, c1515
red pencil, 285 x 425 mm.
Florence, Casa Buonarroti, inv. 1 A verso

19) Michelangelo
Notice for Headmaster Andrea Ferrucci da Fiesole
April 23, 1524
red pencil, 160 x 270 mm.
Florence, Archivio Buonarroti, I, 38 verso

20) Michelangelo
Plan for Bastions, 1527-1528
ink, brown washes, 293 x 412 mm.
Florence, Casa Buonarroti, inv. 22 A

21) Michelangelo
Study for the Head of Leda, 1529-1530
red pencil, 355 x 269 mm.
Florence, Casa Buonarroti, inv. 7 F

22) Michelangelo
Study for a Christ in Limbo, 1530-1533
black pencil and red pencil, 163 x 149 mm.
Florence, Casa Buonarroti, inv. 35 F

23) Michelangelo
Three nudes, 1531-1532
black pencil, ink, 178 x 209 mm.
Florence, Casa Buonarroti, inv. 38 F

24) Michelangelo
Sacrifice of Isaac, c1535
black pencil, red pencil, ink, 482 x 298 mm.
Florence, Casa Buonarroti, inv. 70 F

25) Michelangelo
Plan for San Giovanni dei Fiorentini, 1559-1560
black pencil, red pencil, and brown washes
417 x 376 mm.
Florence, Casa Buonarroti, inv. 124 A

26) Michelangelo
Study for a Gate (Porta Pia?), 1561
black pencil, brown watercolor wash
399 x 269 mm.
Florence, Casa Buonarroti, inv. 73 A bis

27) Michelangelo (replica)
Pietà, original design 1499
cast replica 1982
Bronze, 170 x 170 x 91 cm.
Marinelli Foundry